NEW ZEALAND

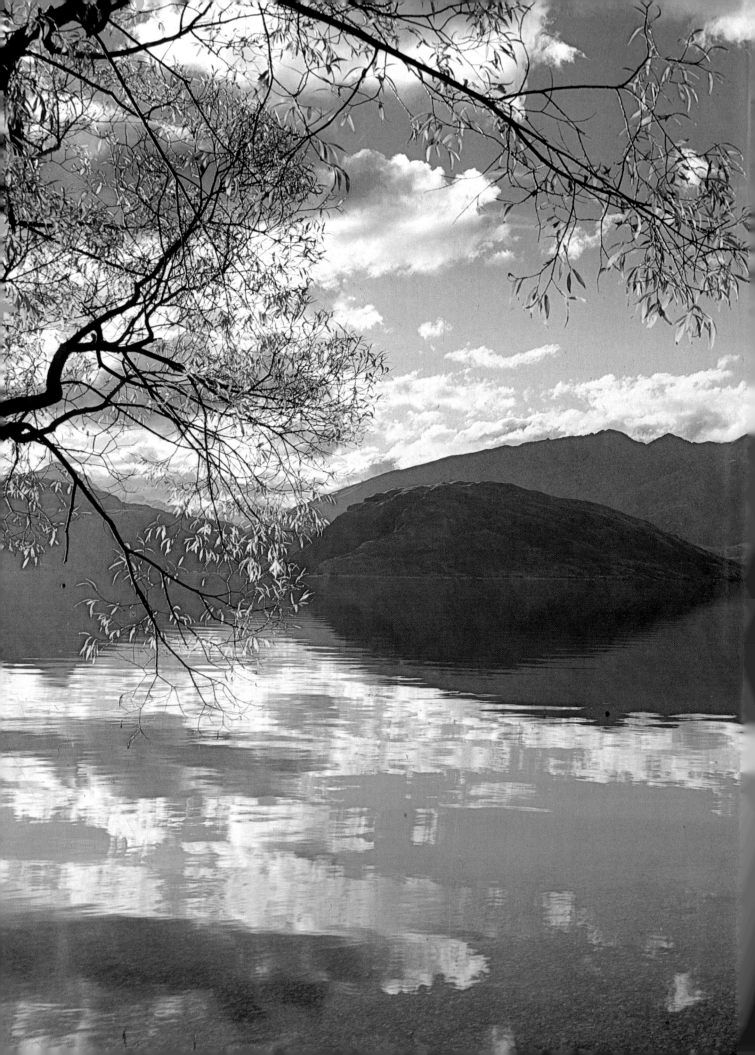

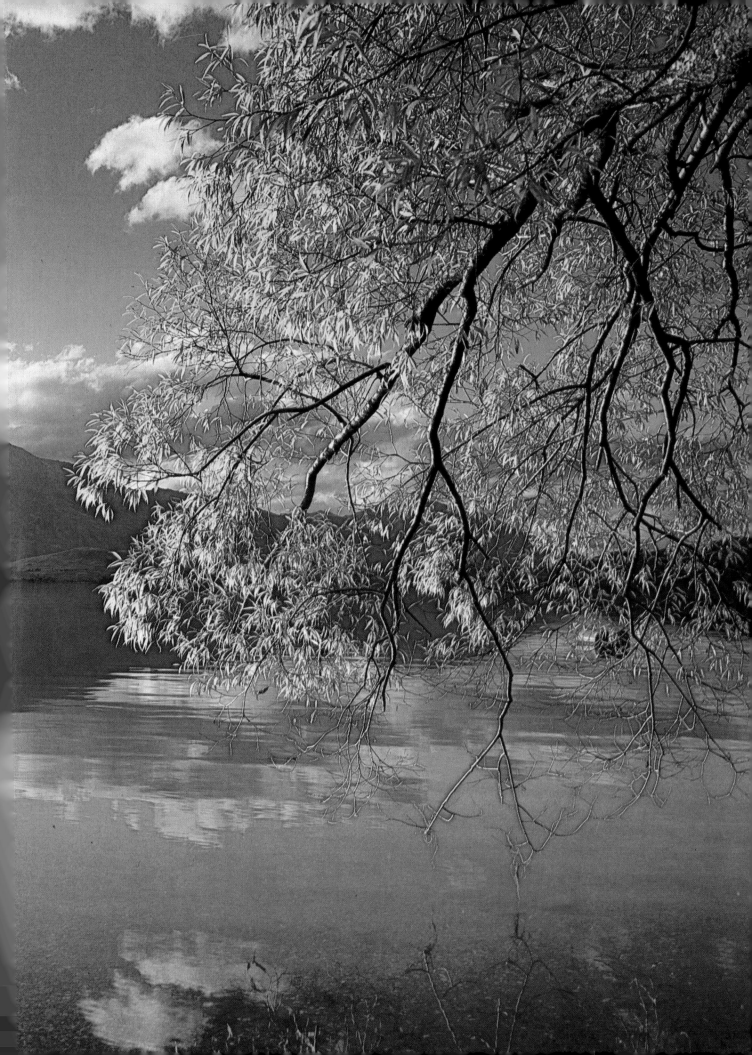

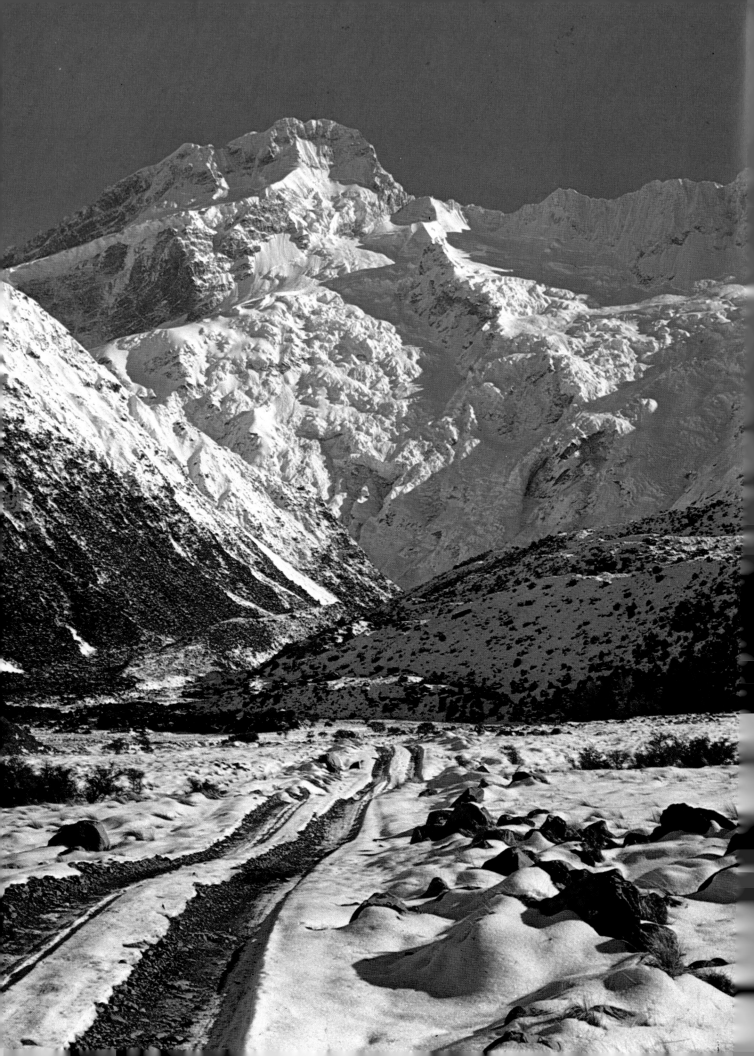

NEW ZEALAND

Warren Jacobs
Lloyd Park
Robin Smith

With text by
Errol Brathwaite

Kowhai Publishing Ltd
Christchurch Auckland

ISBN 0-908598-02-5

Previous Page: Glendhu Bay, Lake Wanaka.
Opposite Page: Mt Sefton.

The Summer Country . . .

Strictly speaking, Northland is that tract of country beginning around about Helensville and stretching northward to North Cape. For me, however, and for the multitude of New Zealanders who head that way for annual holidays, or who eventually retire to somewhere around Keri Keri or Waiheke Island or along the eastern shore of the Coromandel Peninsula, the boundary is climatic rather than strictly geographical.

Northland, you see, is a summer land. Northland is magnificent beaches, superb boating waters, abundant fishing, (including big game fishing), kauri forests, all the principal benefits of island living — and long hot days. Northland is citrus fruits growing in home gardens as prolifically and juicily as plums and peaches do in cooler climates.

Northland is where our people's beginnings are.

I do not mean to suggest that Northland is habitable or enjoyable only in summer. It is, for one thing, an area where you are never far from the sea, and the seacoast climate is, at least in these latitudes, kind. True, the coasts are separated from each other by mountain ranges, the Tutamoe Range in Northland proper, and the Coromandel Range on the Coromandel Peninsula; but these are baby ranges, compared to the "backbone" chain of mountains down through the North Island, and they are hardly mountains at all, beside the mighty Southern Alps. They are friendly, easy ranges you can drive or tramp over, and they are clad to their very tops with beautiful forest, almost sub-tropical in its luxuriance. So there is no fierce, drenching precipitation, no wet coastline on one or other side of the land.

As a matter of fact, it always seems to me that these areas are the essential North Island. Anything that you can find in the rest of the North Island — podocarp forests, thermal activity, fruit-growing, large-scale sheep farming, boating, swimming, seascapes — is present within this relatively small Northland/Coromandel compass; and it is often present on a scale or in a degree of excellence that can be found nowhere else.

What other part of the North Island has a harbour so huge that for many years it had regular steamship services plying its waters? Northland has two. The entire Northland/ Coromandel/Hauraki Gulf area is dotted with habitable, inhabited islands, deep waterways, bays and harbours, including navigable rivermouths, in a measure greater than the rest of the country put together.

But, it is a summer land, primarily. The forests are more enjoyable when you can walk their paths in the warmth of a cicada-loud summer's day. The beaches are happier places where there are hordes of children making the blue, sparkling water laugh. The very roadside banks belong to summer days, with their rose-pink volcanic clays and their wildflowers; and the gardens are brighter for the huge Monarch butterflies, and the coasts for the glory of pohutukawa.

Right
The Bay of Islands. This view from Rawhiti typifies the sheltered excellence of the Bay for boating of all kinds. The waters are usually calm and the weather stable and kind.

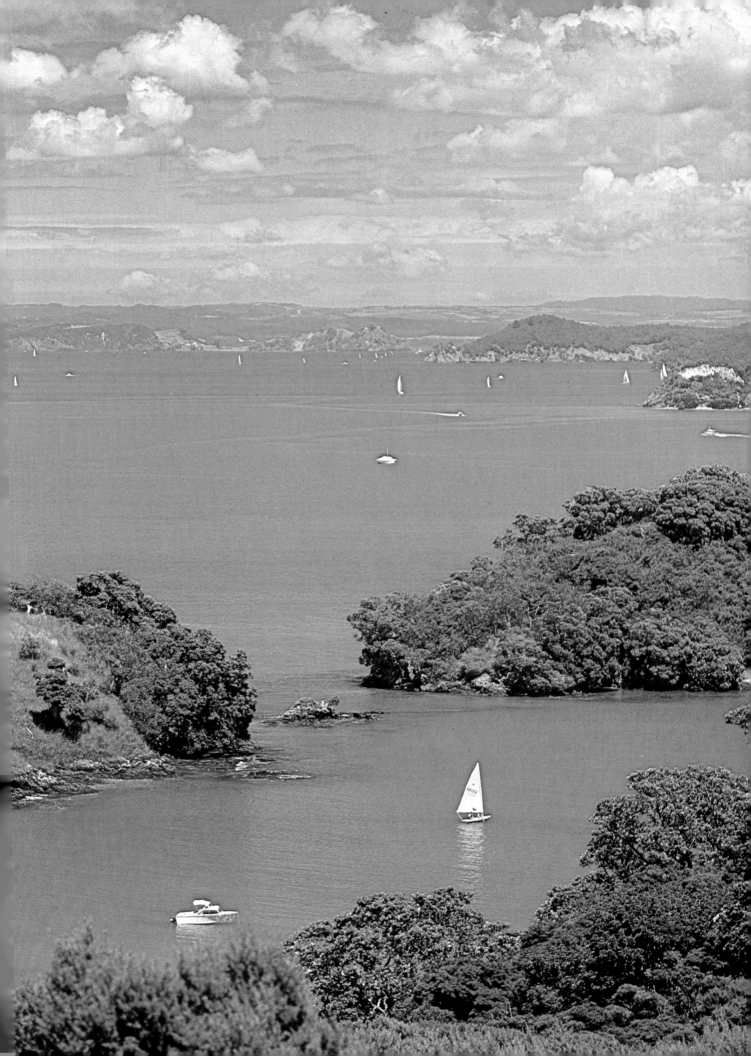

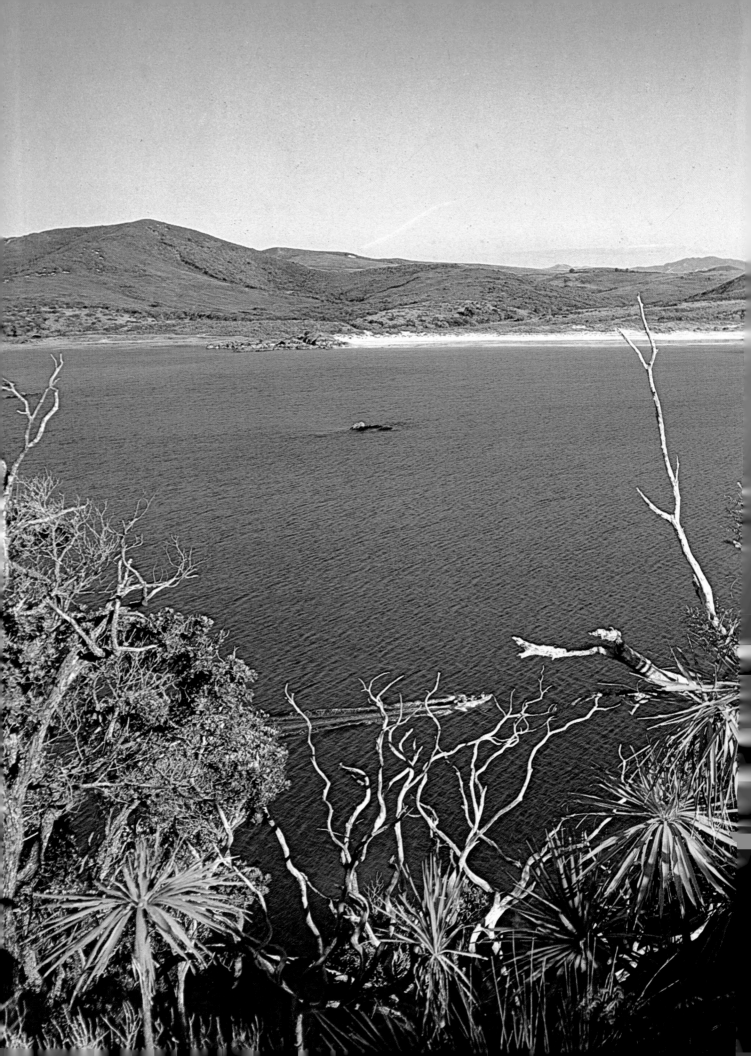

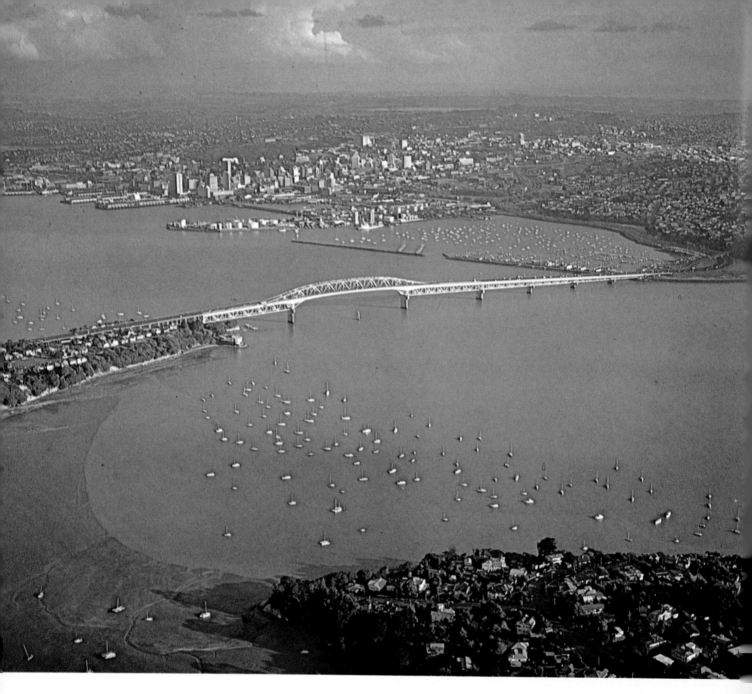

Above
Auckland Harbour Bridge, linking North Shore with the city centre, spans the blue harbour, arching over a confetti-sprinkle of small boats. The southern and western suburbs sprawl over the little volcanic-cone hills to the Manukau Harbour.

Previous Page
Matai Bay, near Cape Kari Kari, is a typical eastern Northland bay, deep and sheltered, ideal for boating and fishing, hemmed by sweeps of golden sand, embroidered with rocky, bush-patched headlands.

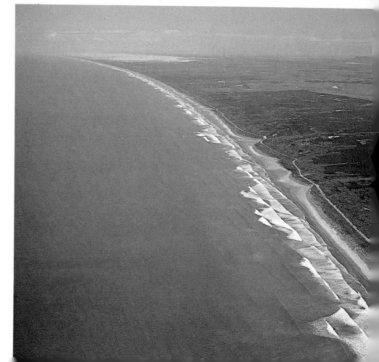

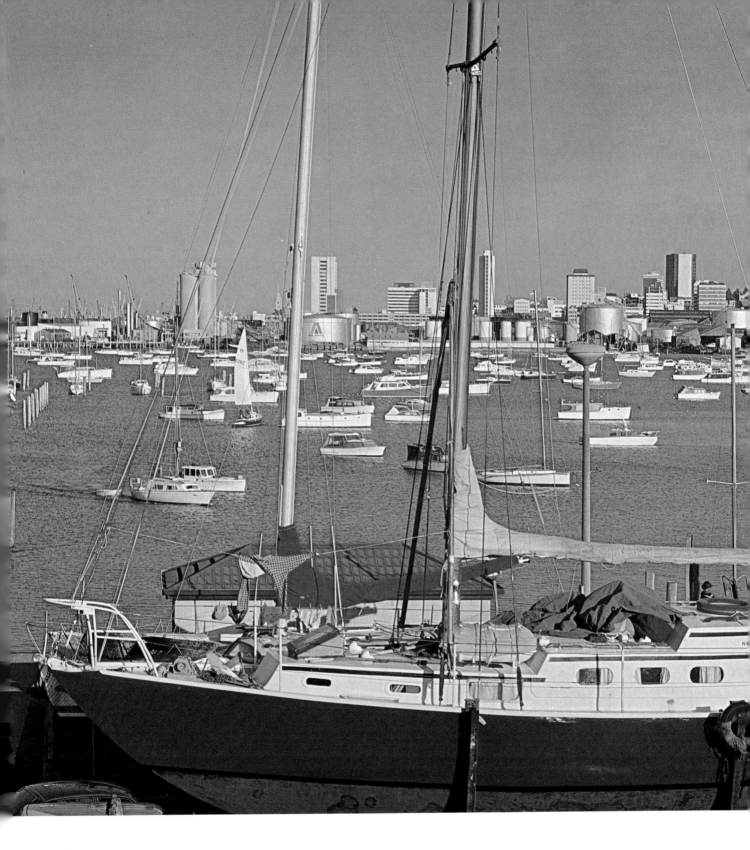

Left
Ninety Mile Beach, sweeping southwards from
Cape Reinga, down the west coast, is actually forty-
five miles in length. Here, toheroas, the highly prized
shellfish delicacy, are found in strictly defined
seasons and areas.

Above
The city of Auckland is seen in this view from
Westhaven Boat harbour. One has the impression of
a gleaming white town, a modern metropolis rising
along the shores of the beautiful Waitemata, with its
high-rise buildings shining in the sun, and its harbour
bustling with commerce.

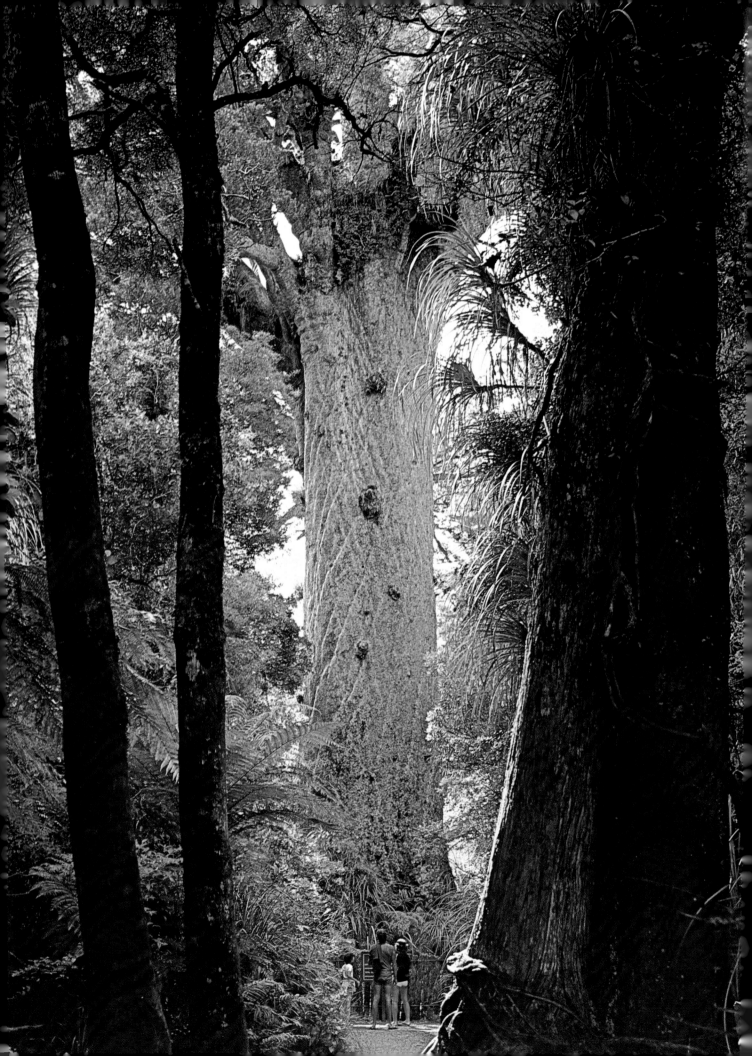

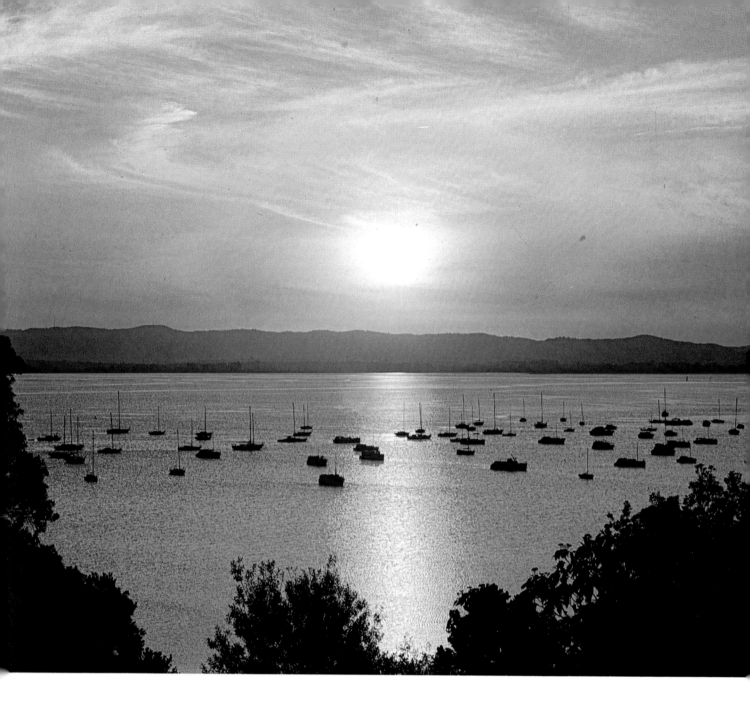

Above:
Birkenhead and Little Shoal Bay, in Waitemata Harbour, Auckland, is usually crowded with small boats. Aucklanders are encouraged by the warm climate to be outdoors people, and few families who enjoy boating are unable to possess, or have access to, a pleasure craft of some kind.

Left:—
Waipoua Kauri Forest is on the main road between Kaitaia and Dargaville. It contains two world-famous kauri trees, ancient monsters known as Tane Mahuta, God of the Forest, some 1,200 years old, and Te Matua Ngahere, Father of the Forest, with a 53-feet girth.

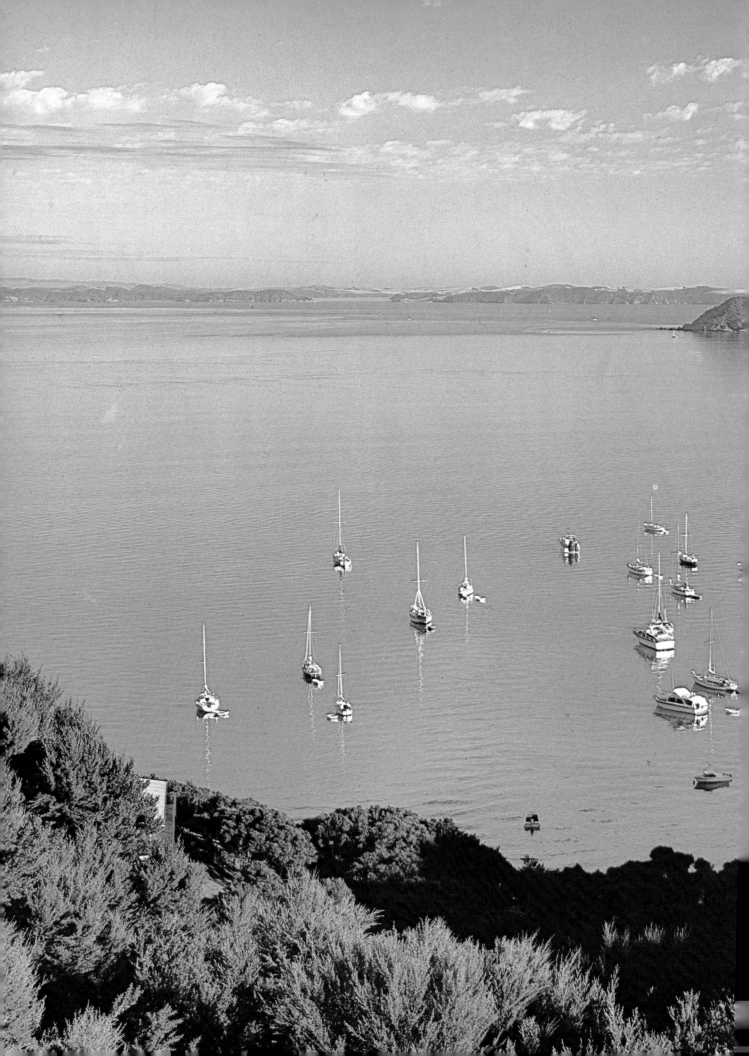

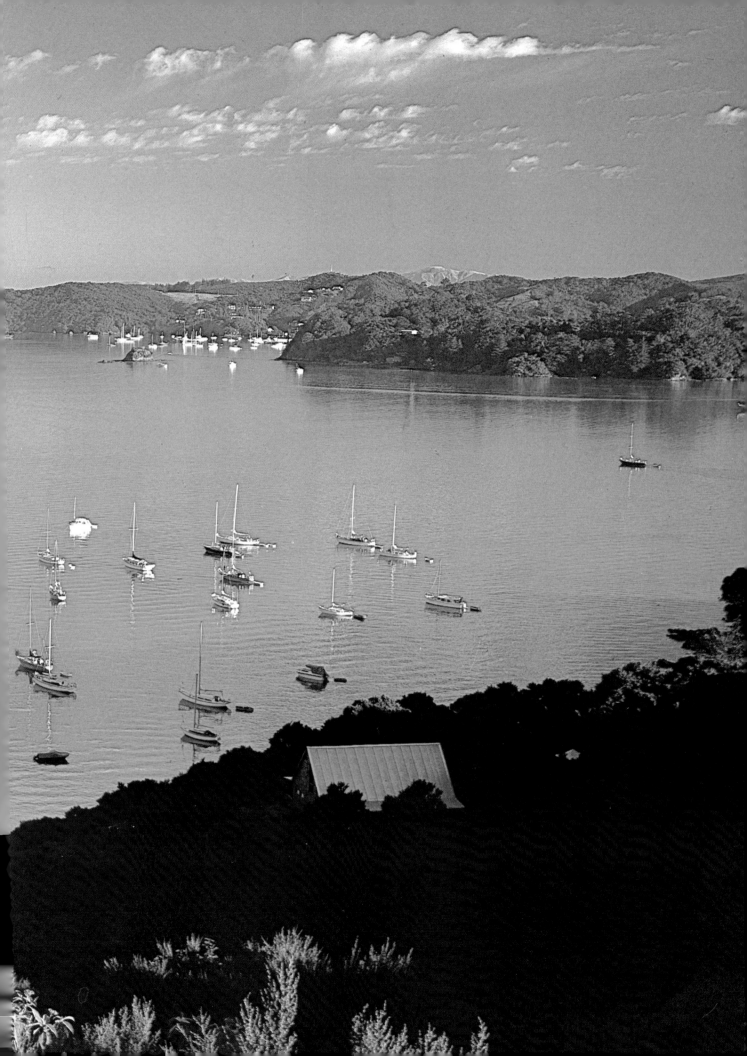

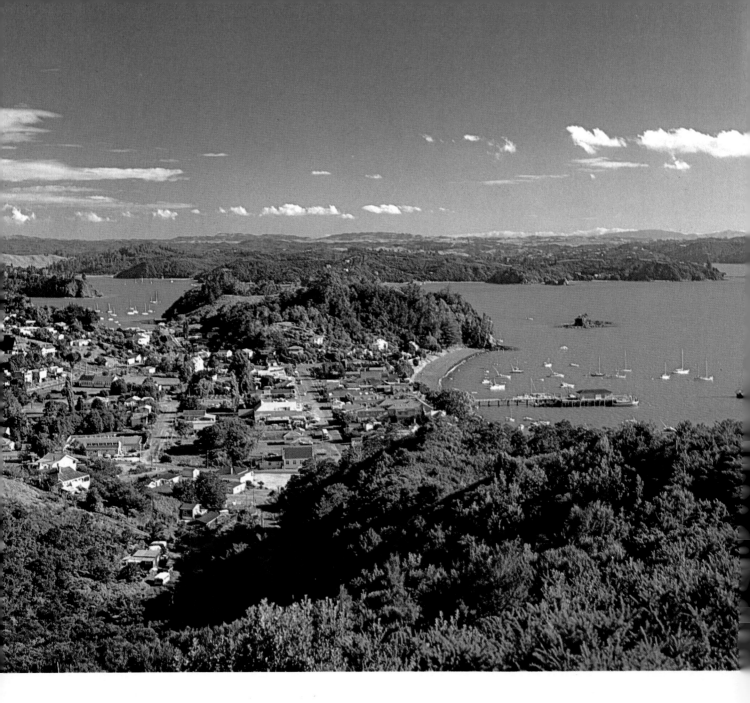

Above

Russell, first European town in New Zealand, was a whaling port. Once known as the hell-hole of the Pacific, it was largely destroyed by the Maoris. The town which arose from its ashes still contains some of the original buildings, grown gracefully old in this haven of peace.

Previous Page

Russell and Pomare Bay, favoured by whalers in the early nineteenth century as an anchorage, now shelters pleasure craft, and enchants the thousands of annual visitors to the area.

Right

Matauwhi Bay, near Russell, is another of the many superbly sheltered anchorages in the area for yachts, fishing launches and smaller craft.

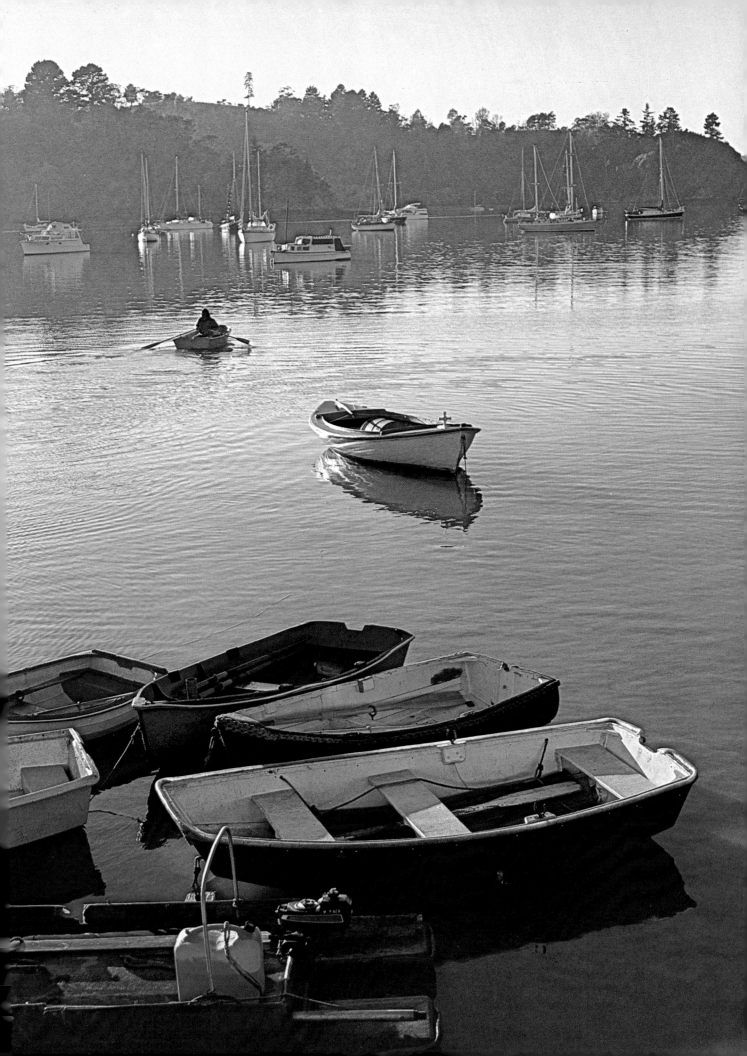

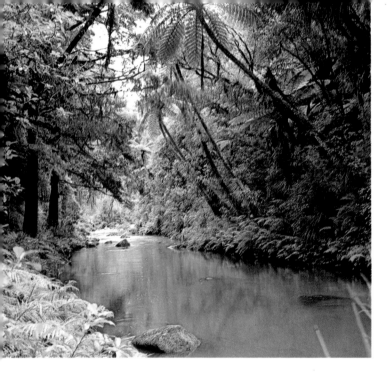

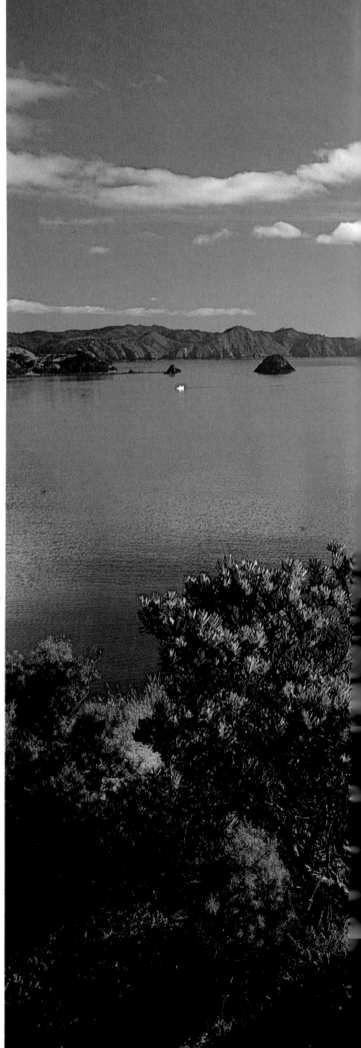

Above
Forest and Stream near Whangarei, typical of the lovely podocarp forest in the area. Whangarei is largely surrounded by forest, fingers of which reach into the city's suburbs. Settings like this abound within easy reach of the heart of this bustling town.

Right
Mercury Bay, on the Coromandel Peninsula, from where Captain James Cook observed the transit of Mercury in 1769. Fine catches of schnapper are obtained in this bay, and big game fishing has brought in fine specimens of Black Marlin, Striped Marlin, Mako Shark, Thresher Shark, Tuna and Kingfish.

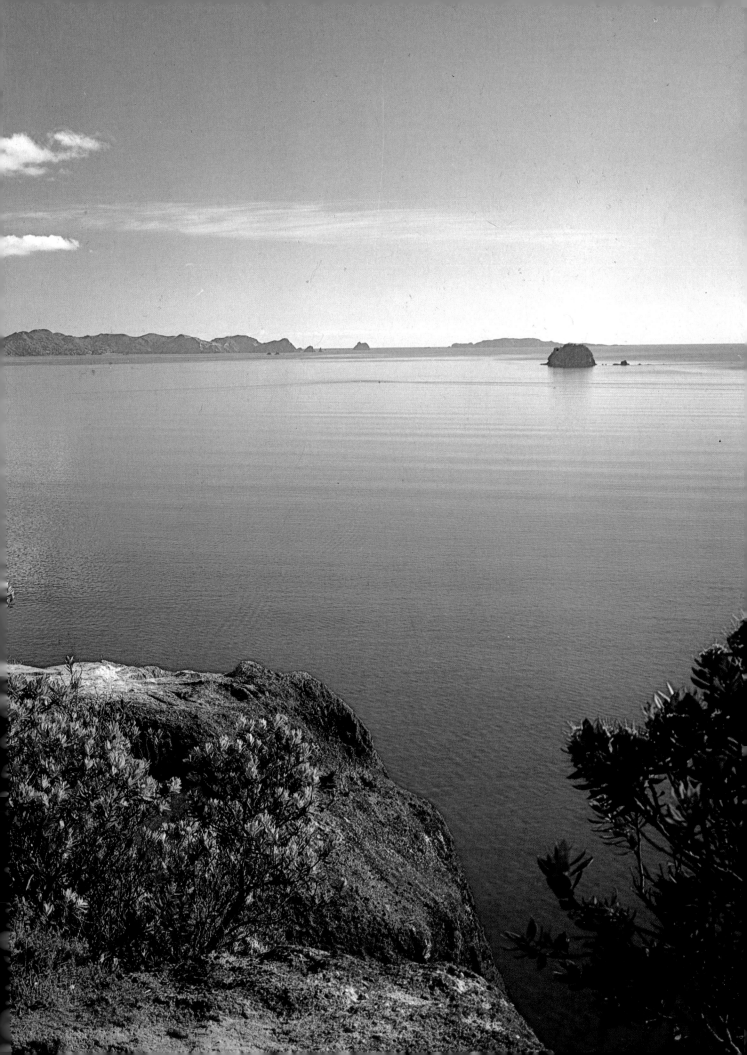

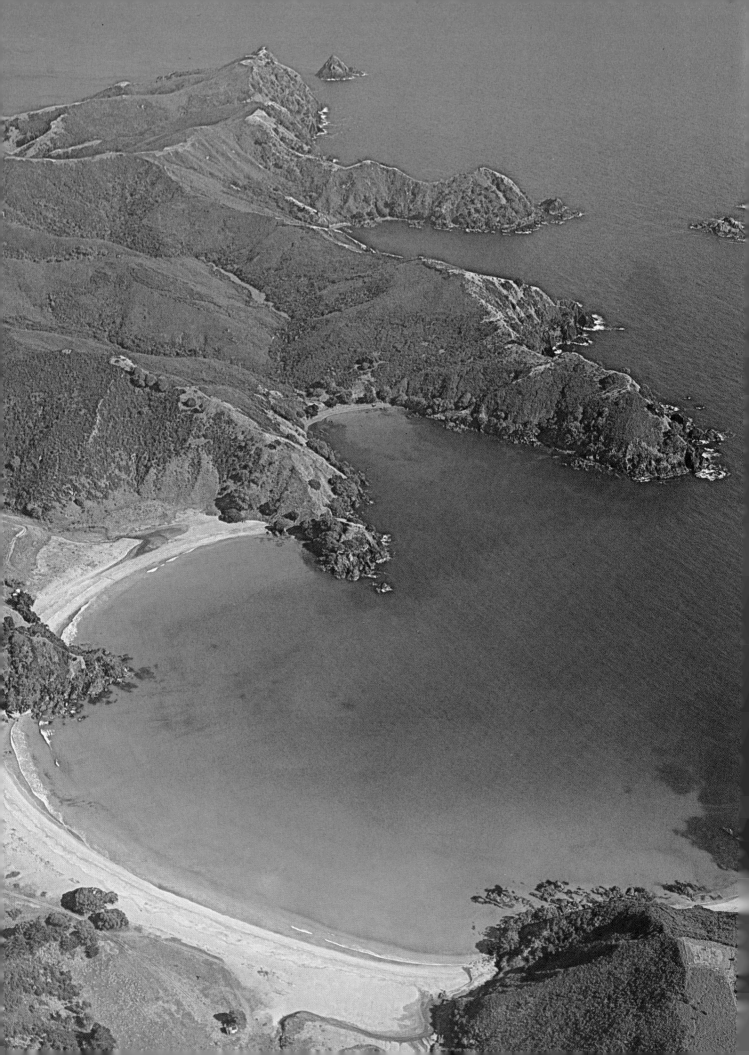

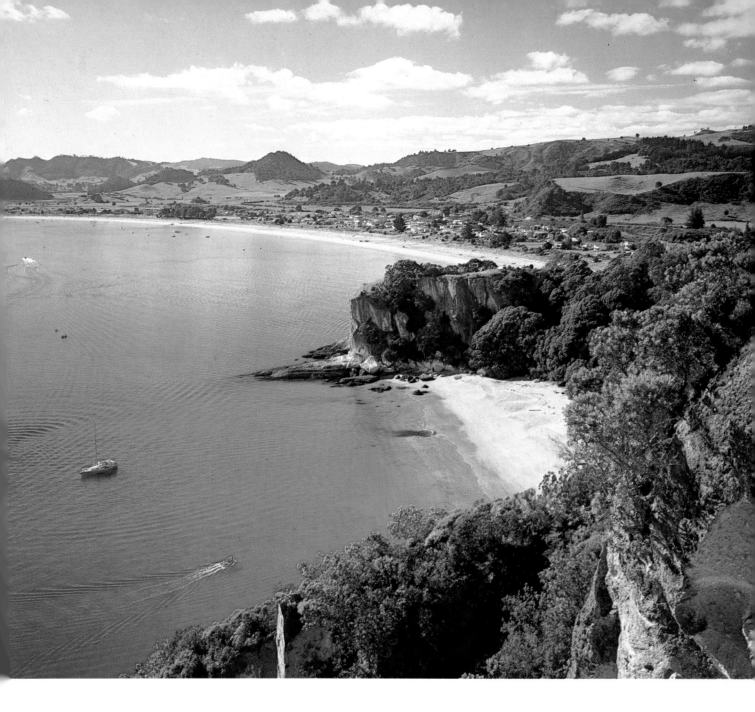

Above
Cook's Bay and Lonely Beach, Coromandel —
sheltered little coves, fine sweeps of golden sand,
where bathing is safe and the pohutukawa climbs
over the enfolding, rocky headlands.

Left
Taemaro Bay, an interrupted curve of clean,
shining sand enfolded and protected from the
sometimes boisterous waters of Doubtless Bay by
the spurs of a hilly little peninsula thrusting their
rocky tips into the sea.

The Morning Land . . .

If you take a map of the North Island, and draw a line more or less straight down from Auckland to Taumaranui, and from Taumaranui across to Hastings, you will fairly neatly enclose most of the more spectacular indications that this land is very young, still heaving, steaming, hissing and bubbling from the cataclysmic cauldrons of its birth. Much of the world must have been like this in the early morning of its aeons-long day.

There are other areas in New Zealand, and particularly in the North Island, which reflect this primeval quality, notably the central volcanic massif just south of our arbitrary Taumaranui-Hastings line; but it is within these boundaries that the early-world quality is most coherent, least interrupted.

It isn't only the thermal activity, though this is marked. It is the denseness of its forests, its clean and jewel-like lakes, its vast solitudes, its vestiges of animal breeding and life-cycles continuing as they were before man arrived, as though man had never existed, had never disturbed the even tenor of their ways.

Much of it is tidy, organised, well-drilled country, beautifully barbered areas where old-world trees and that restful quiet so reminiscent of the English rural scene spread deliciously and warmly under the fierce sun and the burning ocean light of the Pacific sky. But it also contains huge areas which are untamed, innocently wild and not quite formed into what, in ages to come, they will be.

It is still, for me, a summer land, a land whose principal attractions are its beautiful coasts, its gloriously situated lakes, its rivers which idle down to the sea, its orchards, its vineyards, its harbours and its mountain ranges which, though higher than the Northland hills, are still mountains which, for the most part, can be driven, walked or at least scrambled over.

The coastline runs down around the Bay of Plenty, swinging sharply northeast and turning at East Cape to pursue a curving course southward, to Gisborne and Poverty Bay. It is interrupted by the roughly ten-mile length of Mahia Peninsula before it curves deeply inward to form Hawke Bay.

Its topography is diverse; rugged, forested tangles of high ranges hiding lakes like captive seas, ranges which reach out as diminishing spurs into rich, rolling farmland. It is a land like Biblical Canaan, flowing with milk and honey, wooded, watered by silty streams and strongly flowing rivers, possessing a soil so rich that the early settlers had a saying: "Tickle the earth with a hoe and it laughs a harvest."

It is a land of thoroughbred horses growing strong and hardy, with matchless endurance, on the downs about Matamata in the northern Waikato. It is the land of pretty, hedged farms on the green, flat river terraces around Cambridge and Hamilton. It is the land of dusty sheep single-filing around the ridged limestone hills of central Hawke Bay, at day's end, heading for water in the cool of the evening. It is the land where the early sunlight touches the tip of Mount Hikurangi on the East Cape, like the first flame of a signal beacon in the darkness.

It is the morning land . . .

Right

Whanarua Bay is an idyllic indentation at the base of Cape Runaway, on East Cape. Sandy shored and safe, sheltered by reefs and shaded on the hot summer days by eucalyptus and flaming pohutukawa, it may be fairly described as a deliciously peaceful retreat. Indeed, even its name suggests something of the kind. It means "Company of two people."

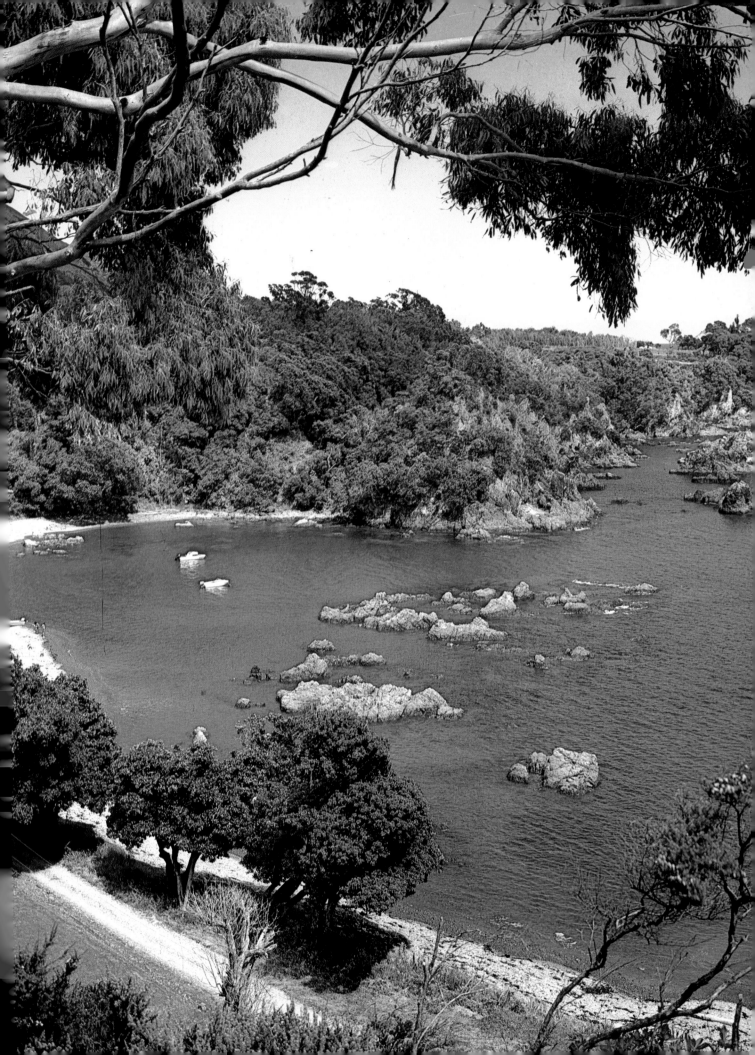

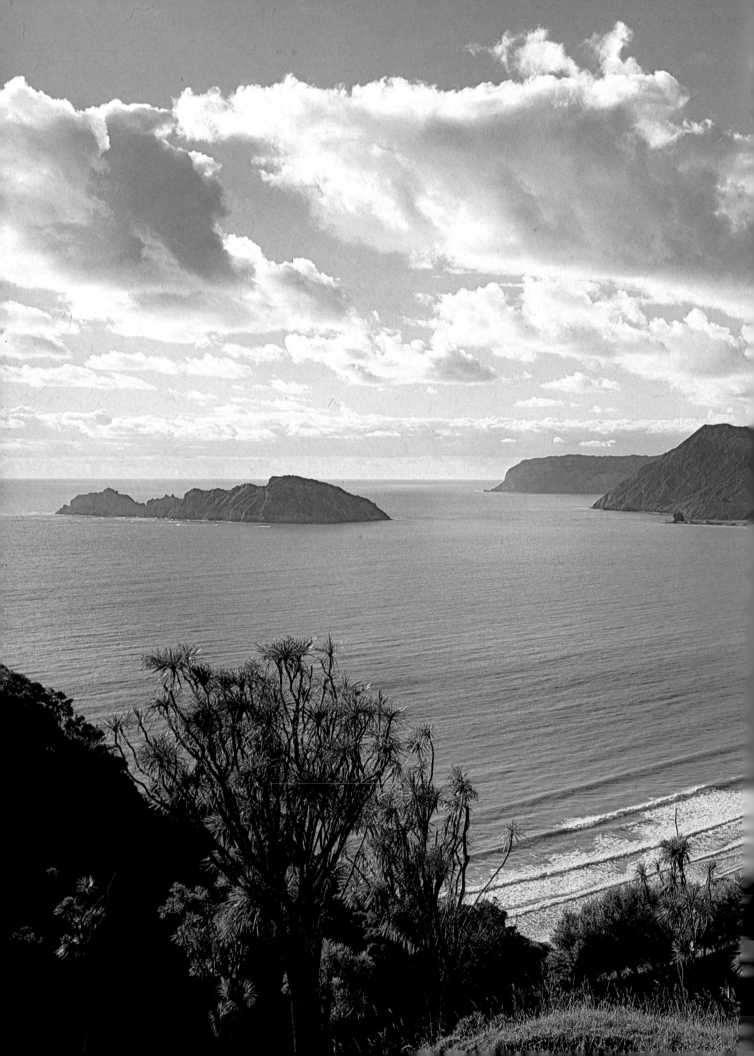

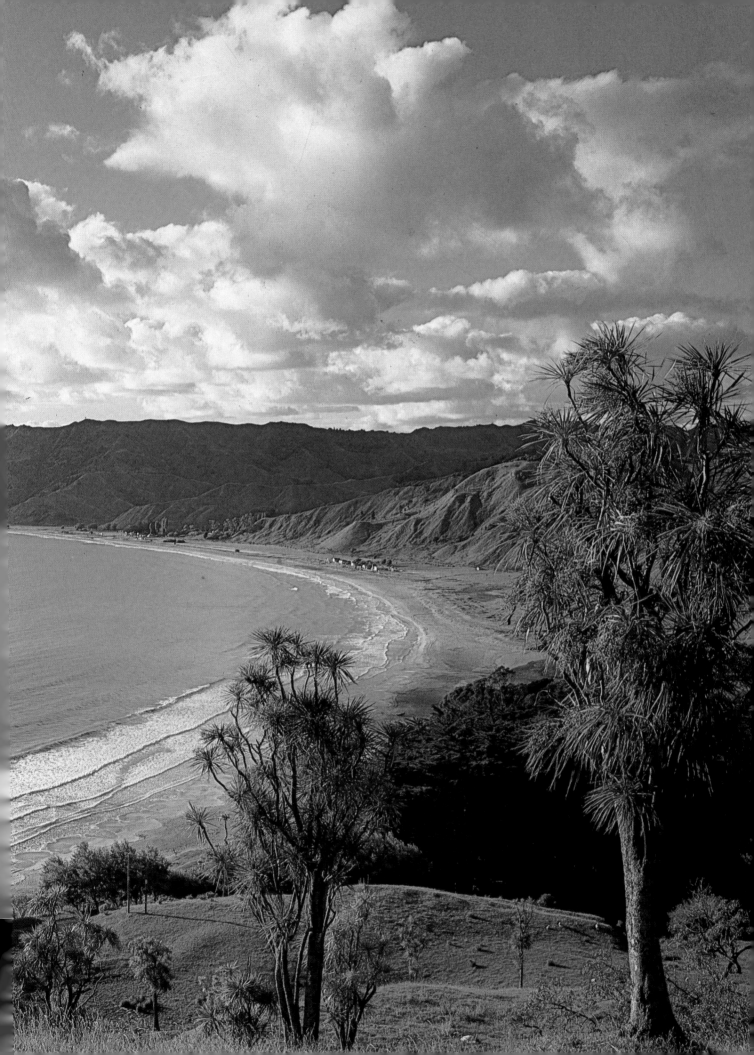

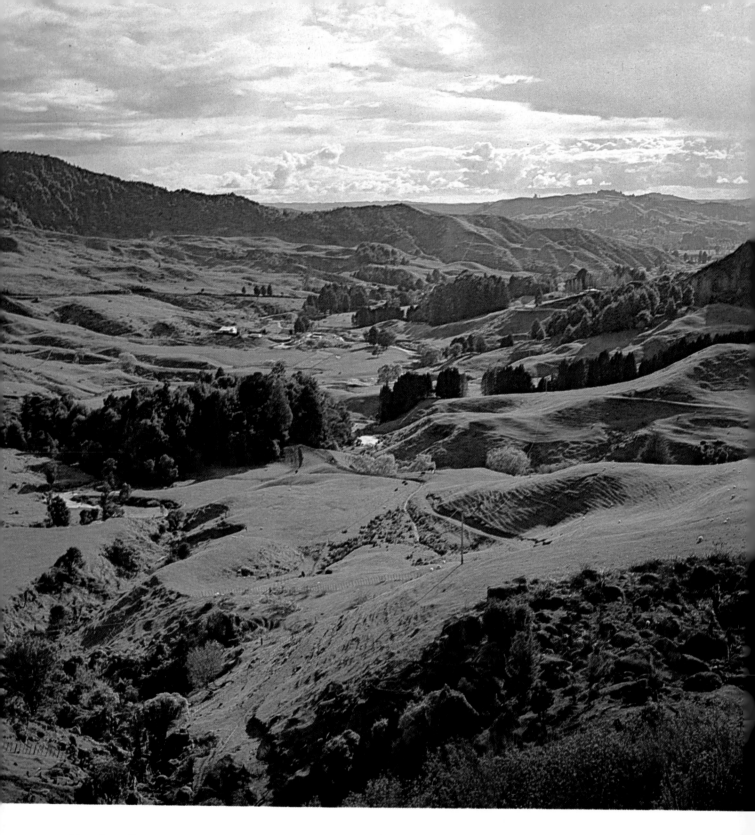

Previous Page
Anaura Bay, midway between East Cape and
Gisborne, is a reasonably sheltered stretch of coast,
though not more so than many similar bays in the
vicinity. Captain Cook chose to send his men ashore,
here, for wood and water, because a creek runs
down across the beach. The landing was probably
rough, because they called the place Tegadoo, which
was the nearest they could get to local
pronunciation. It is most likely that the word was not
a name, but the Maoris' commentary on conditions
— "Te Ngaru", meaning "Heavy surf."

Above
Piriaka is a farming district near Taumaranui. These
hills, ridged and narrowly terraced by sheep tracks,
were once heavily wooded, and watercourses and
very steep faces are still clad in native bush. This is
typical of central North Island sheep country, and
valleys like this are common for perhaps a hundred
and fifty kilometres north and south of this point.

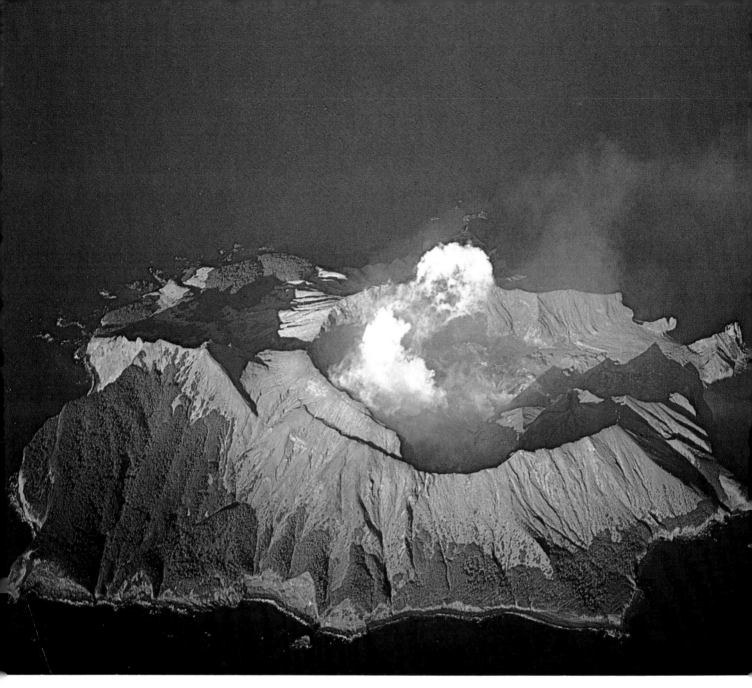

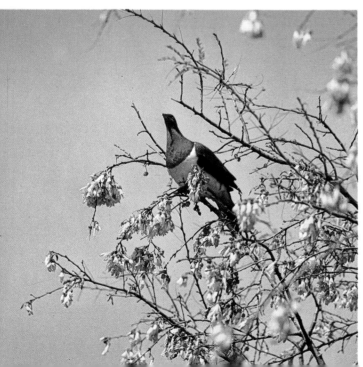

Above
White Island smokes and smoulders off the Bay of Plenty coast, some 56km, as the seagull flies, from Opotiki. It is an awesome place of spitting fumerols and acid lakes, for it is still very much an active volcano, marking the beginning of a volcanic fault-line which stretches almost in a straight line from White Island, down through the Rotorua Taupo area, to the three volcanoes, Tongariro, Ngauruhoe and Ruapehu.

Left
Kereru, the native pigeon, is a friendly and beautiful inhabitant of the forest's fringe.

27

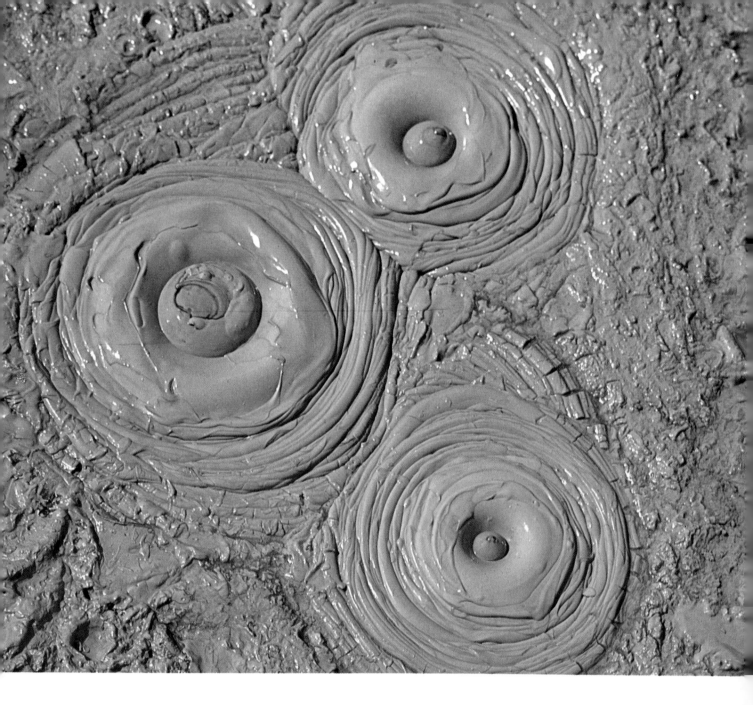

Above
Bubbling mud in the Waimangu Valley, slurping
and puffing like boiling porridge, is a reasonably
passive indicator in an area of frantic and spectacular
thermal activity at the south western end of Lake
Rotomahana, that this land is still young. Here was
the Waimangu Geyser, which used to erupt
regularly, hurling boiling water, mud and large rocks
up to 500 metres into the sky. It is now quiescent,
except for its furiously boiling pool.

Right
Pohutu Geyser is perhaps the most famous of
Rotorua's thermal attractions in the Whakarewarewa
Valley, an area possessing pretty well all of the
thermal or volcanic phenomena. Here the Tuherangi
sub-tribe of the Arawa people live, their houses and
their families making full domestic use of the
unlimited supplies of naturally boiling water.

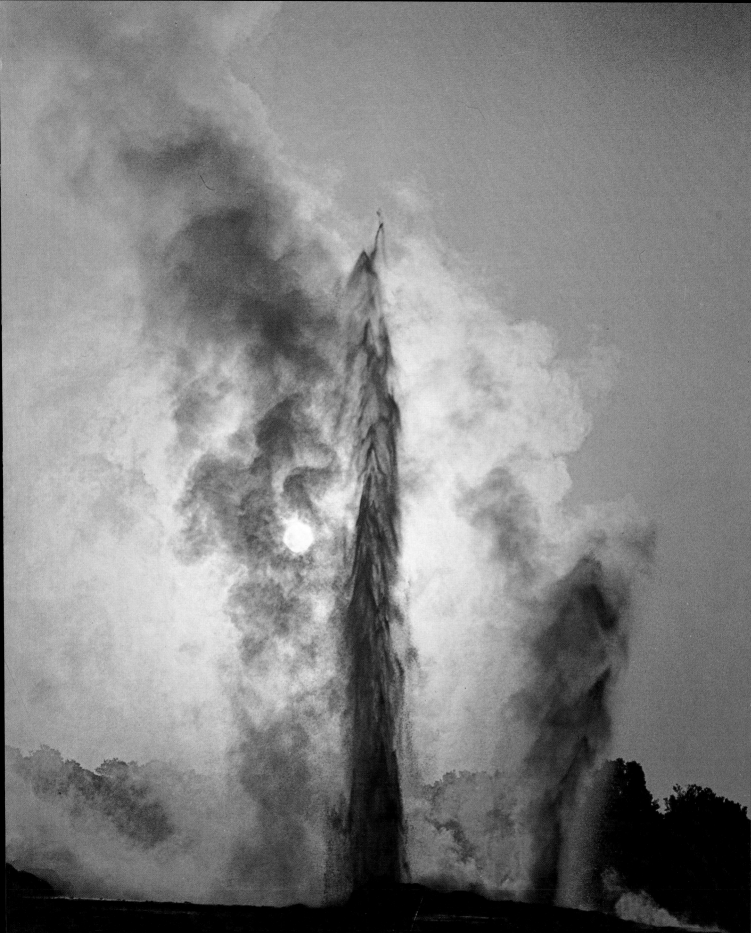

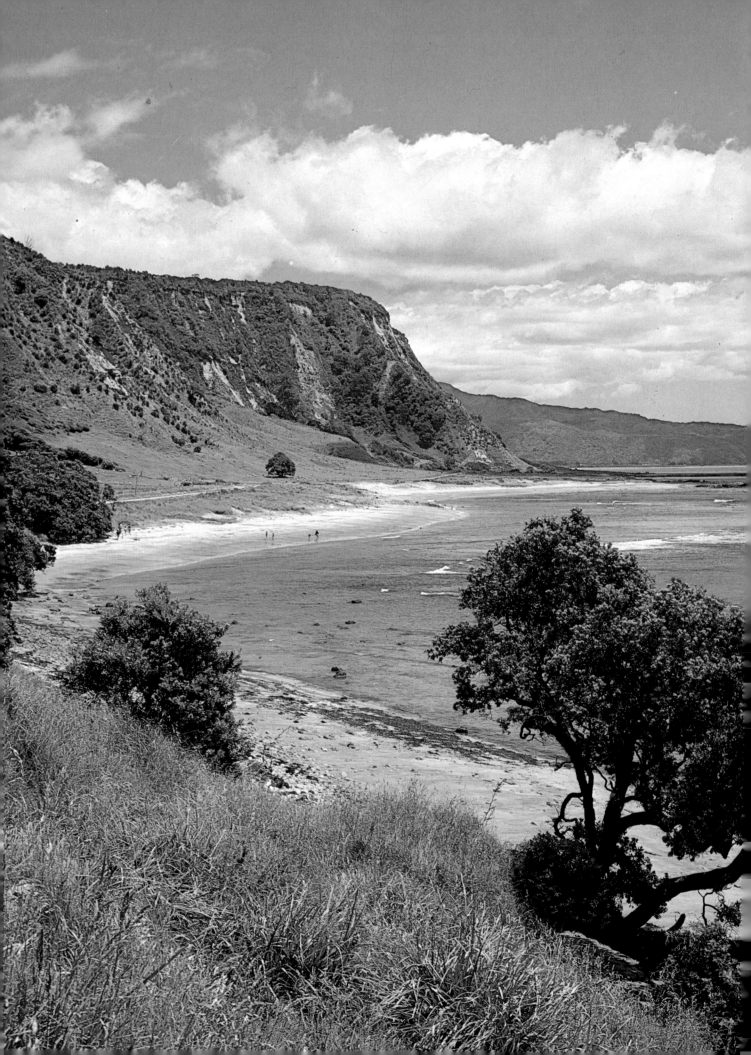

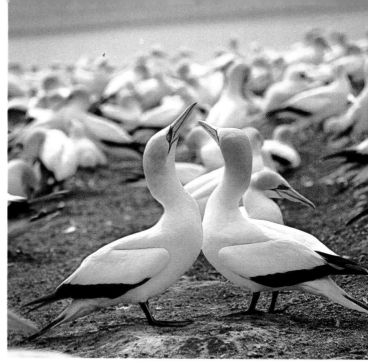

Above

Gannets on Cape Kidnappers, the southern
extremity of Hawke Bay, have two large nesting
areas. On the long, razor-backed ridge, the gannets,
which are relatives of the pelican, have been nesting
for aeons, and they pay little attention to Johnny-
come-lately humans who walk (supervised) amongst
them and admire their chicks. They possibly regard
us as a passing nuisance, but nothing to be unduly
alarmed about.

Left

Kawakawa Bay is typical of the coastal scenery in
the vicinity of East Cape, with its towering
escarpments, its white beaches and its pohutukawa
trees, in December all blazing with scarlet blossom.
The name is a pointer to the original homeland of the
Maori race. In full, it is Te Kawakawa-mai-tawhiti,
which indicates that the name came from Tahiti.

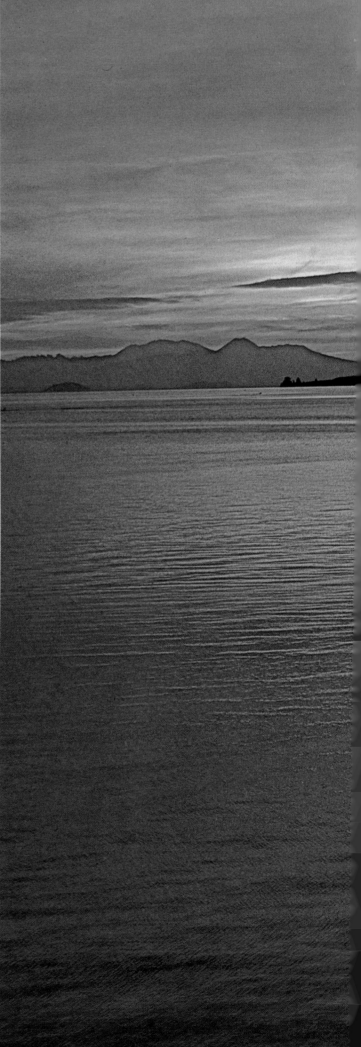

Right
Lake Taupo is New Zealand's largest lake. Almost in the centre of the North Island, it is some 40km long by 28km wide at its widest point. The Maori name for the lake was originally Te Moana-nui-a-Tia, The Great Sea of Tia. Tia, who was a Maori explorer, found a high cliff on the lakeside which resembled a type of flax cape, known as a taupo. He called the cliff Taupo-nui-o-Tia, the Large Shoulder Cape of Tia, and the name, abbreviated to, simply, Taupo, was eventually applied to the lake itself.

Below
Pania of the Reef, though human in appearance, was a taniwha, a monster, who lived in the sea. Like Hans Anderson's Mermaid, she fell in love and married a human being, but was eventually recalled to the sea, and forbidden to return to land. She may be seen in the bay off Napier's shore, a shadowy, humanoid shape in the form of a reef. This statue is on Napier's Marine Parade.

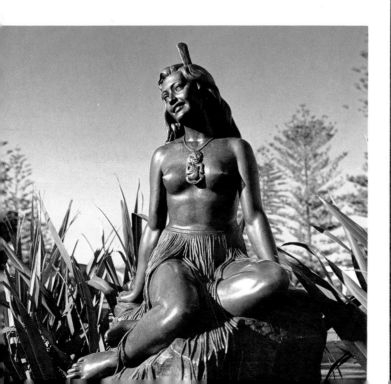

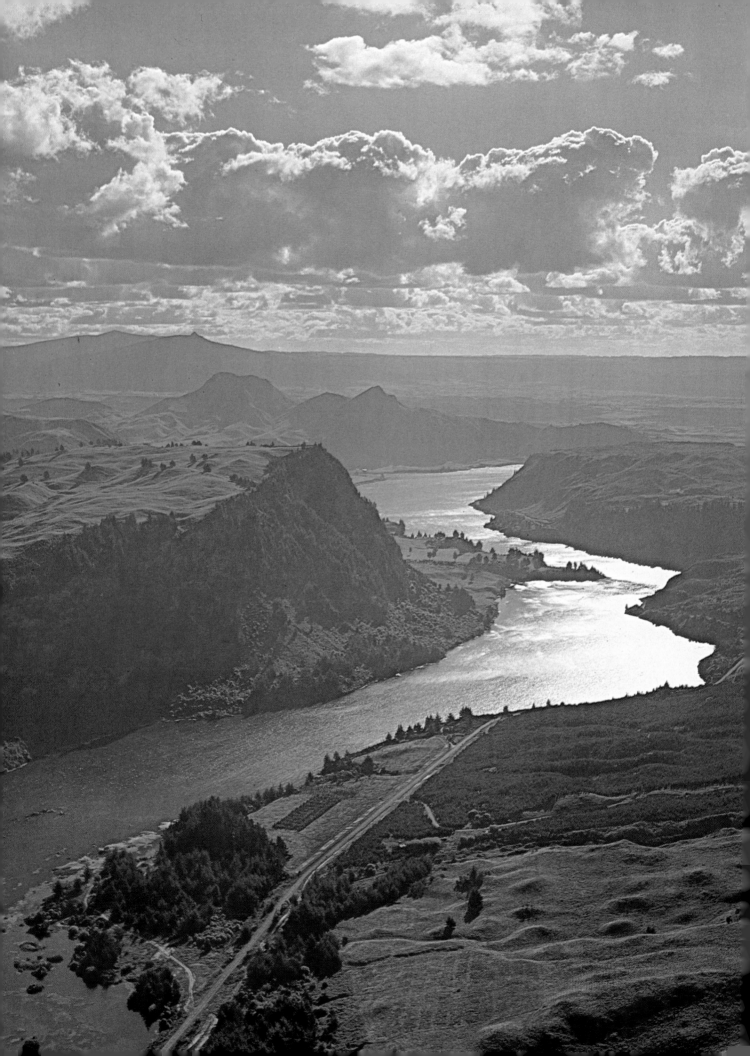

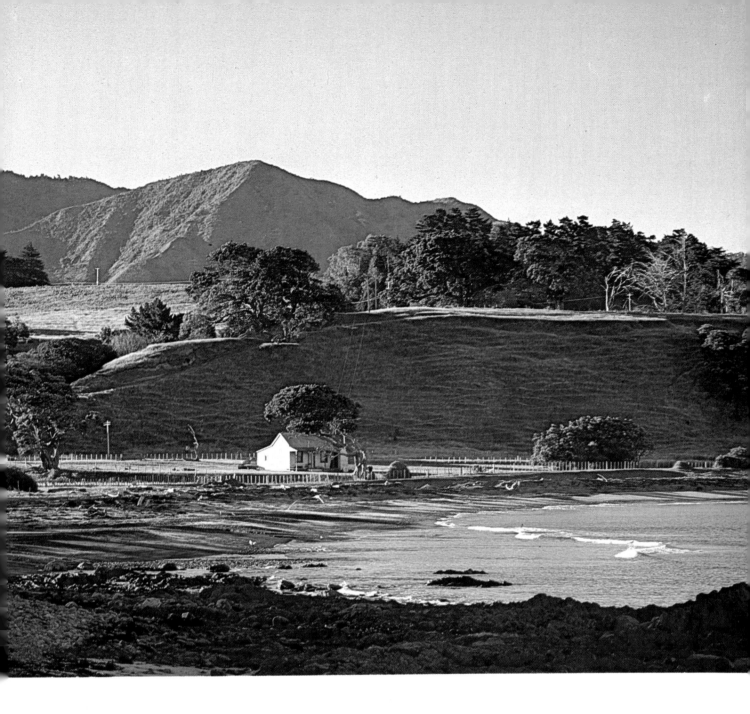

Above
Raukokore Bay is a delightful spot on the Bay of
Plenty, southern shore, which is the northern shore
of East Cape. Here, the steep and forested hills stand
back a little from the peaceful shore, where the full
force of the ocean rollers is tamed a little by reefs,
and directed full upon a shelving beach.

Left
Whakamaru Lake, on the Waikato River, is not
really a lake at all, but a reach of the river,
interrupted by a hydro dam. On the whole length of
the swift, turbulent Waikato River, there is no
other reach, free-flowing or interrupted, that, from its
banks, looks quite as lake-like. Here, in the river's
middle basin, it is broad, calm, cupped between high
hills and bluff headlands; yet for all its easy-going
mood, the current is powerful enough to turn electric
turbines. The name means "to shade or shelter."

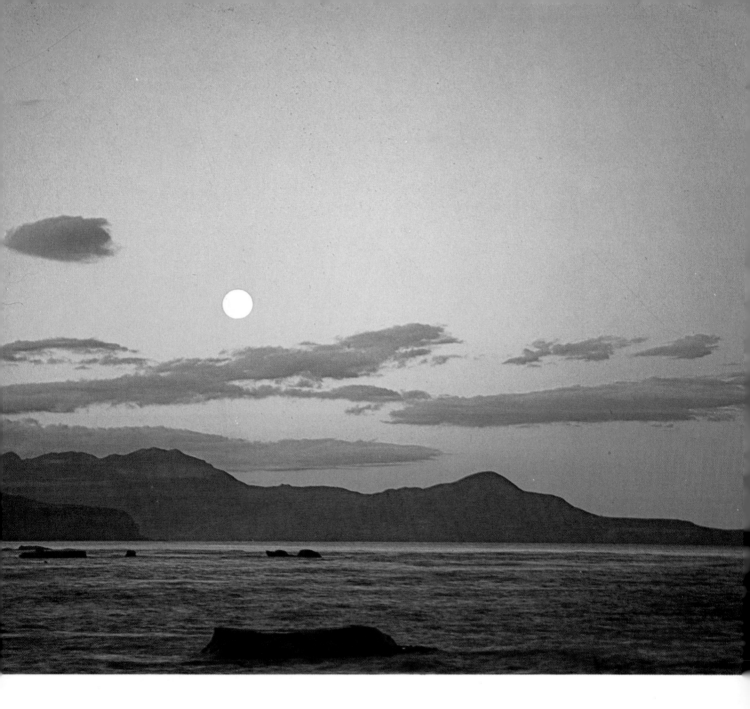

Above

Motukaoa Point, sheltering the northern end of
Hicks Bay on East Cape, is today a somewhat lonely
place, a loneliness somehow emphasised by this
sunset scene. The point was negotiated by Captain
James Cook in 1769. He gave it a reasonably wide
berth, for the coast hereabouts is somewhat rock
bound. He likely saw it in just such a time and mood
as this.

Right

Te Wairoa Falls cascade down a tumble of rocks at
the edge of a broad shelf on which is Te Wairoa, the
Buried Village, entombed in a great thickness of
volcanic ash when Mount Tarawera, at the far end of
nearby Lake Tarawera, exploded in 1886. The
beautiful forest recovered or regenerated. The village
did not.

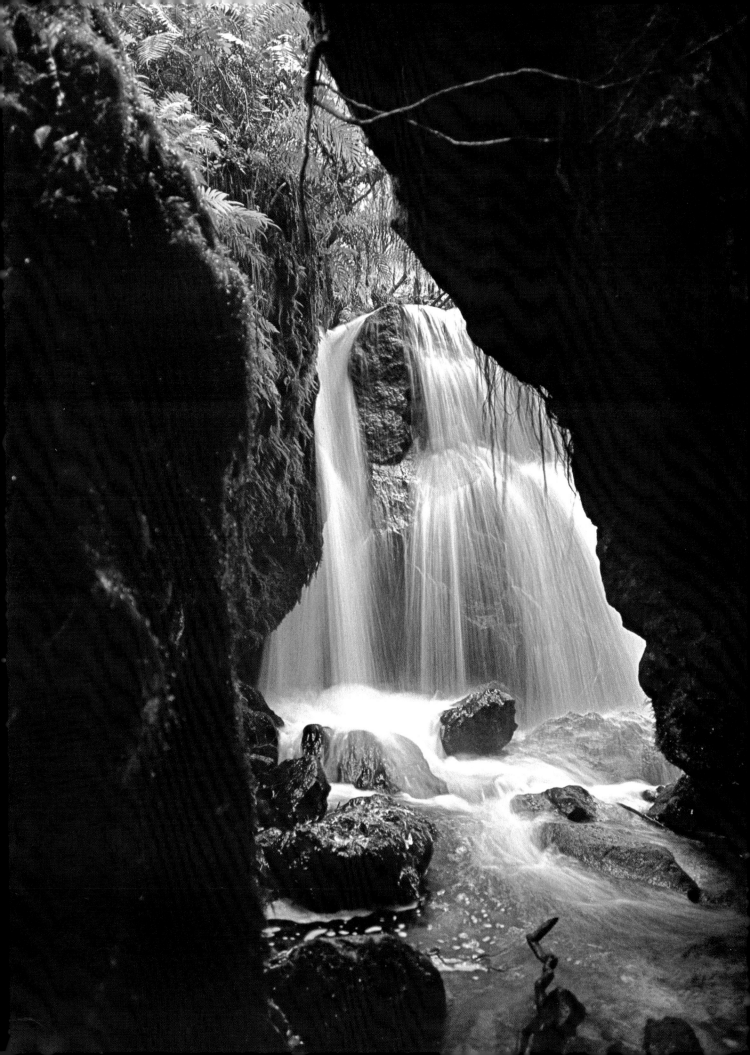

Ports, Peaks and Pastures . . .

Almost in the centre of the North Island, just south of Lake Taupo, are the three volcanic cones, Ruapehu, Ngauruhoe and Tongariro, all active in one degree or another. They rear up to a considerable height from the central volcanic plateau, Ruapehu qualifying as the highest peak in the North Island, a respectable 2,796 metres (9,174ft) high, usually snow-crowned in spite of its volcanic activity, and providing excellent skiing.

From the plateau, the country falls away to the west and south, crumpled, twisted country, complexes of high ridges, often densely forested, interspersed with stretches of gentler land where the dark native bush gives way, for a time, to poplar and exotic pine, and the fields are open and lushly green.

There are great rifts in the valleys, where rivers have buffeted and carved their way out of the tangle of ranges in their rush to find the sea.

To the west, Mount Egmont lifts its beautifully symetrical cone to the sky, drawing up the surrounding land with it, all folds and pleats like a draped skirt. To the south, the Kaimanawa Range and the Ruahine Range form the backbone of this fish-shaped island which the old-time Maoris, with more navigational and geographical knowledge and comprehension than we know, called Te Ika-a-Maui, the Fish of Maui.

Separated from the Ruahine Range by the Manawatu River, the Tararuas continue southwards to link with the Rimutaka Range, and from the Rimutakas the Orongorongo Range branches off in a complex of wooded spurs, to the very rim of Wellington Harbour.

To the east of this mountain wall, the land rolls away to form some of the finest sheep-farming country in New Zealand. To the west, it flattens out ever so slightly to the sea, and the glorious beaches of the South Taranaki Bight, until the lateral spurs of the Tararuas stick out towards the coast at Otaki, and dip their feet in the sea, grudgingly allowing a narrow ribbon of road to climb around and over their toes to reach Wellington, the capital, where it sits in its amphitheatre around its magnificent harbour.

This is green country, high rainfall country, west of the ranges, with a generally drier, warmer climate to the east, in central and southern Hawke Bay and the Wairarapa. In the main, those portions of the western side where the land is closely presided over by high peaks or ranges, and the rainfall is high, dairy farming is, if not the principal, then at least an important industry. There are considerable sheep-farming areas, especially in the King Country, in the Mangaweka Valley and around Fielding.

On the eastern side of the mountains, sheep-farming predominates, and what dairying there is, is largely for town supply.

It is a land of mountain peaks — Egmont, (2,518 metres), Mitre, (1,570 metres), Hector, (1,528 metres); and mighty rivers, the Wanganui, navigable, about 230km long, and the Manawatu, about 160km long, second largest in the North Island.

With gargantuan limestone reefs running southward through it, it is an area of extensive caves and underground river systems, spectacularly carved gorges and odd rock formations.

And it goes almost without saying, that it is beautiful. In this area can be found mountain scenery, desert scenery, rain forest, seascape and magnificent rivers. It contains four fine, landlocked harbours and two major ports — and every inch of it is interesting to look at, hundreds of square miles of kaleidoscopic delight.

Right
Mt Egmont, often referred to as New Zealand's Fujiyama, has not quite the perfect symmetry of the Japanese volcano. A small secondary peak, Fantham's Peak, projects from one side of it like a slightly hunched shoulder. Egmont stands alone, though the remains of a second, awesomely shattered peak forms its foothill ranges. Sometimes described as an extinct volcano, Egmont is actually dorment.

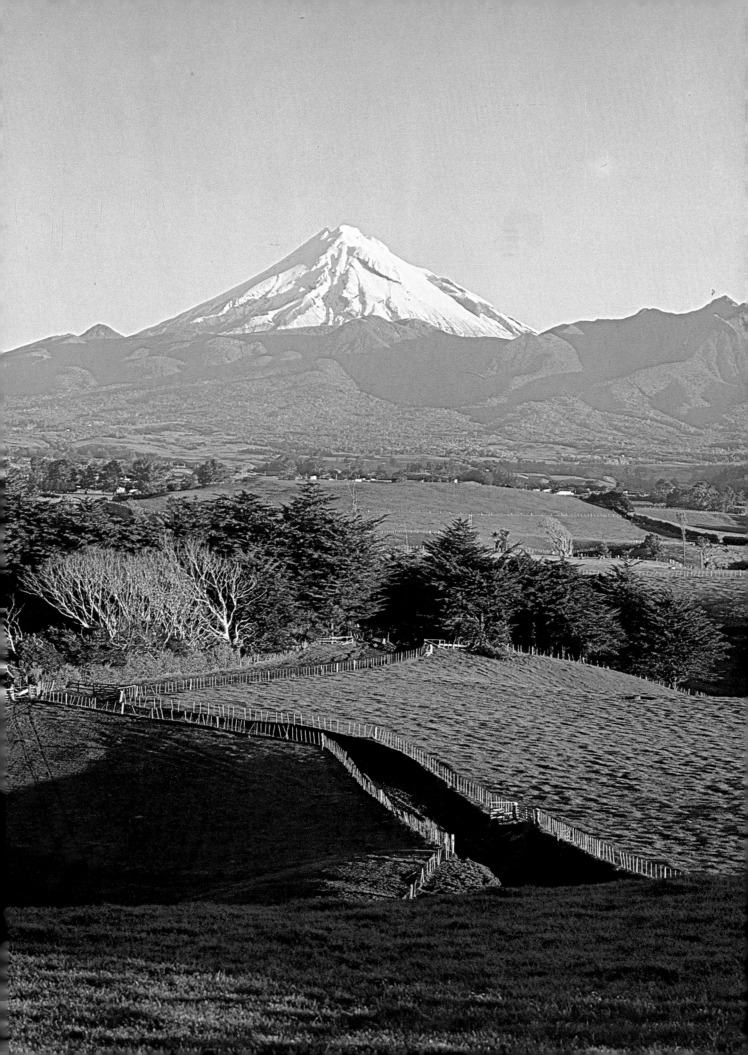

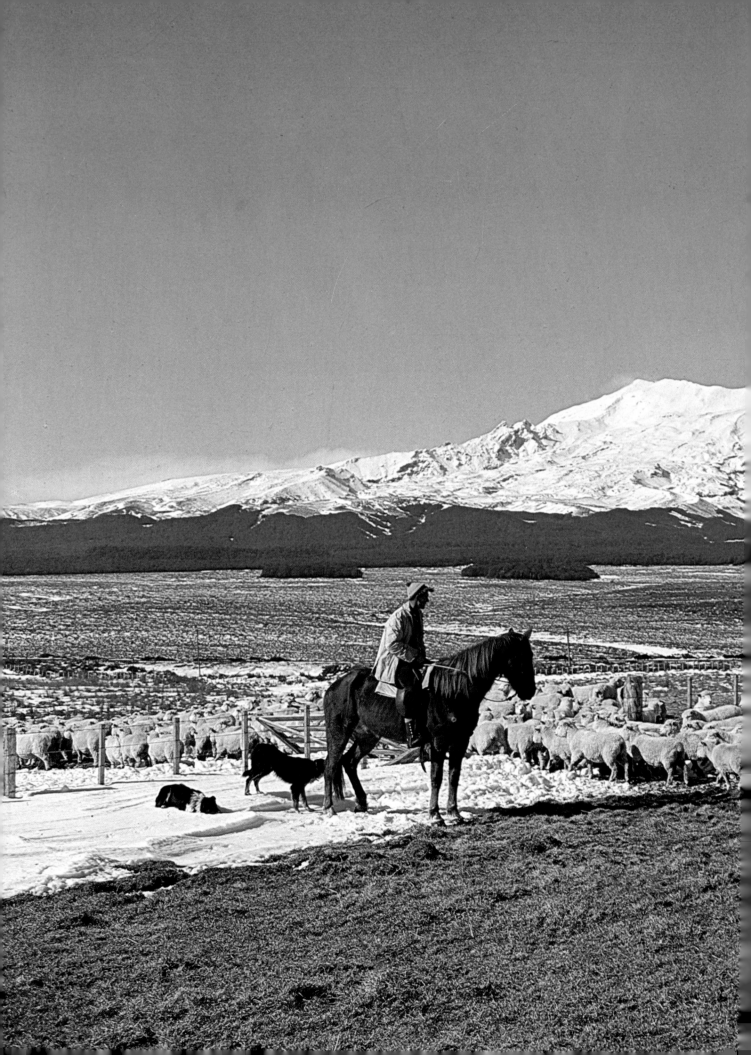

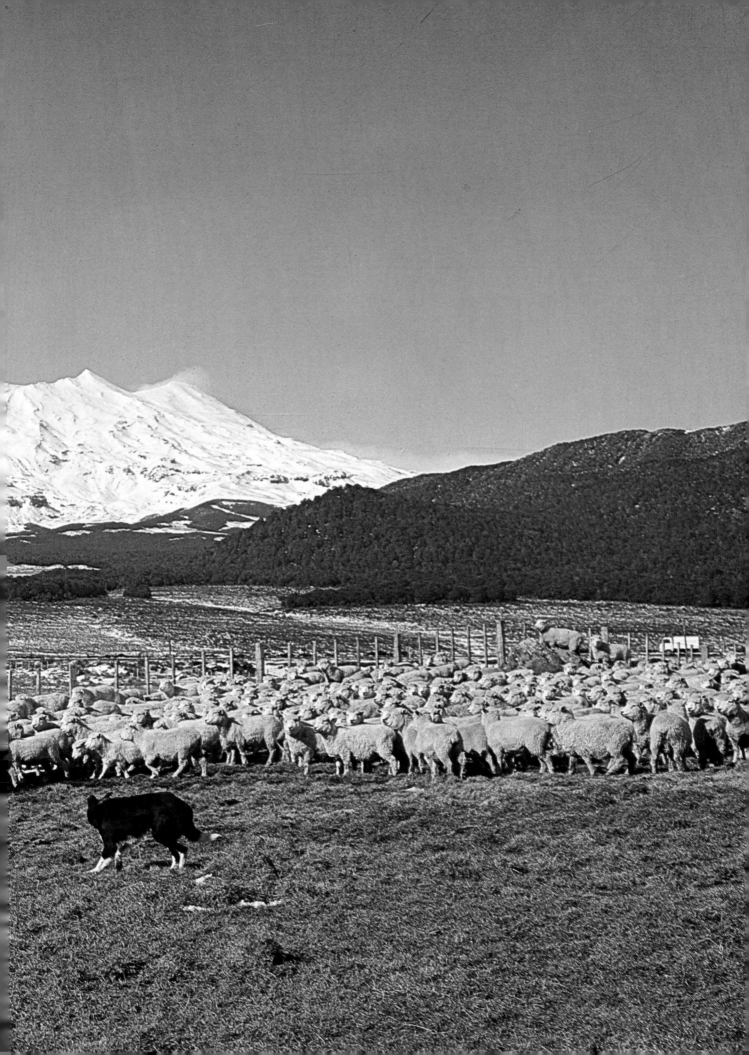

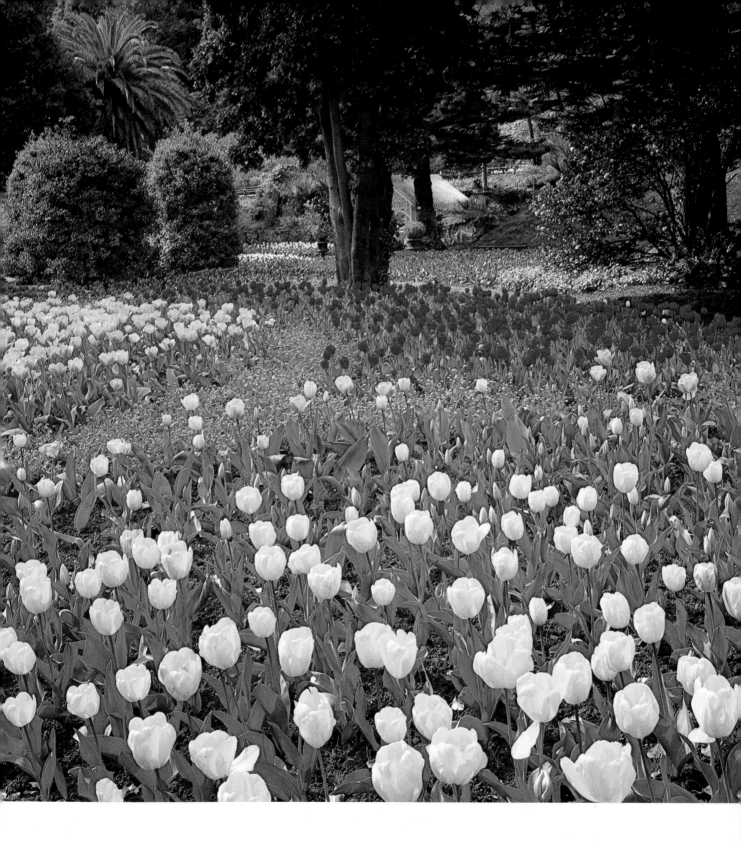

Previous Page

Ruapehu's truncated cone, clad in impeccable white, shines across a high, cold, winter landscape which is, nevertheless, some of the finest high-country sheep farming land in the North Island. Winters here are harsh, summers often burning hot, a characteristic it shares with Central Otago; and, as in Central Otago, it is inhabited by a special breed of men, self-suffcient, hospitable and hardy.

Above

Wellington is almost a city in a forest. In its suburbs, spread around the deep valleys and precariously perched on the sides of the hinterland hills, each section around each home has been literally carved out of the bush and tall scrub. Yet there are well-tamed areas, such as the Botanical Gardens, where the respectable formality of rose gardens, and lawn-bordered flower beds such as this magnificent display of tulips, contrasts with the cheerful scruffiness of the native bush.

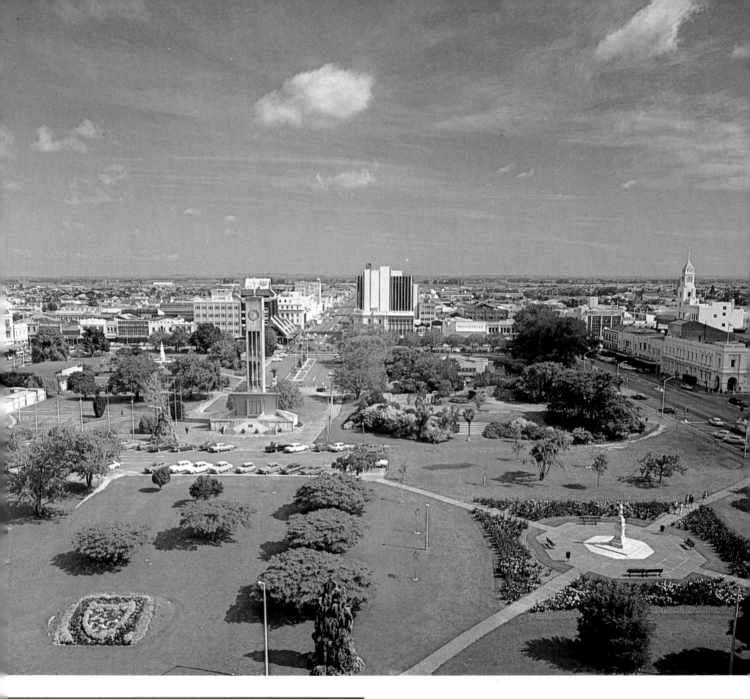

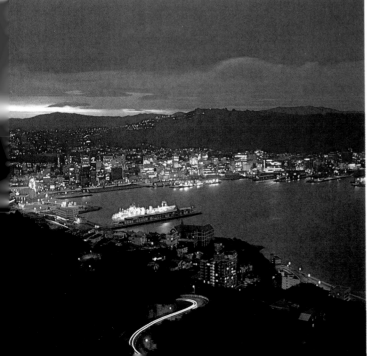

Above

Palmerston North City forms a sort of crossroads, from where major routes lead off to Auckland, Wanganui and New Plymouth, Hawke Bay or south to Wellington. A pretty town, its spacious central square was, until recent times, bisected by the railway, which now, more fittingly, has been removed to the outskirts of the city, leaving an unencumbered 16 acres of lawn, garden and tree-shaded walks to form a most attractive centre for the city's main shopping area.

Left

Wellington, New Zealand's capital, is a city which has managed to crowd its business and administrative heart into a few narrow hectares at the edge of its superb harbour. It has managed to do so, first by pushing some of the surrounding hillsides into the water and reclaiming building sites from the sea, secondly by erecting soaring high-rise buildings.

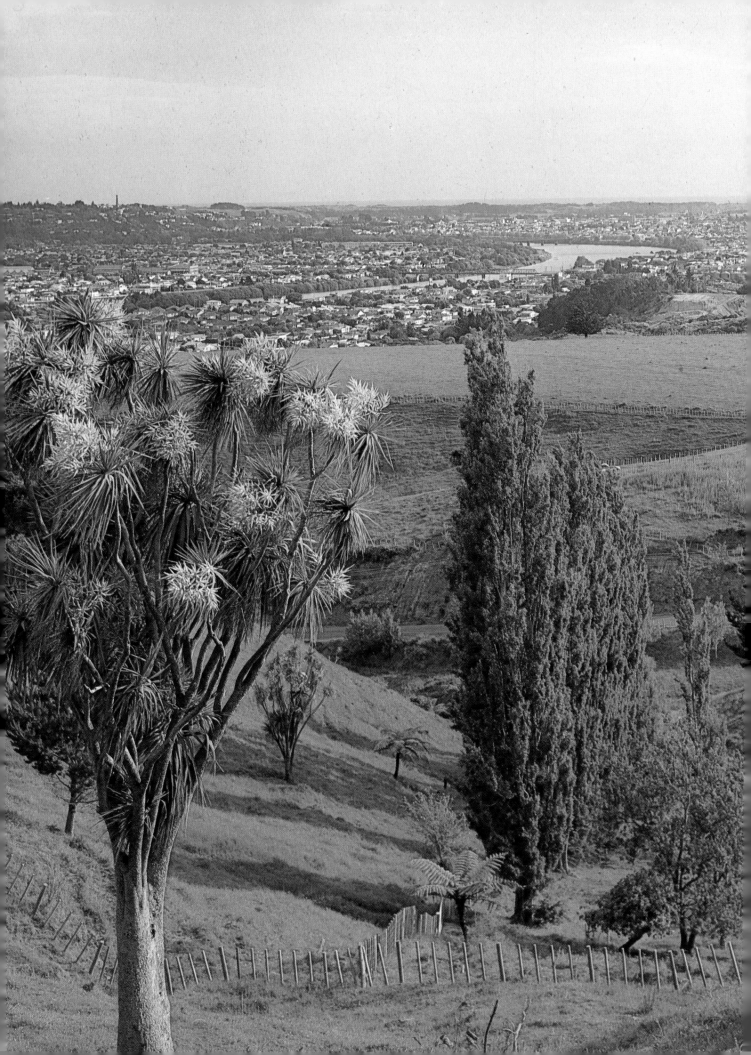

Left

Wanganui is a fine, beautiful and progressive city, the centre of an agricultural and pastoral district. Often described as a "garden city", it is pleasantly picturesque, with superbly landscaped public reserves and many delightful public gardens. The city sits on the banks of the Wanganui River, surrounded by well-barbered, green and peaceful farmland.

Below

The Wanganui River has been called, with some justification, the Rhine of New Zealand. Roughly 230km in length, it rises on the western side of Mount Ngauruhoe and, swelled by numerous tributary streams, has carved its way down to the coast, where the southern side of the west cape swings southwards towards Wellington. This reach, near Taumaranui, is still deep, wide and navigable, though only jet boats seem to disturb its placid surface nowadays.

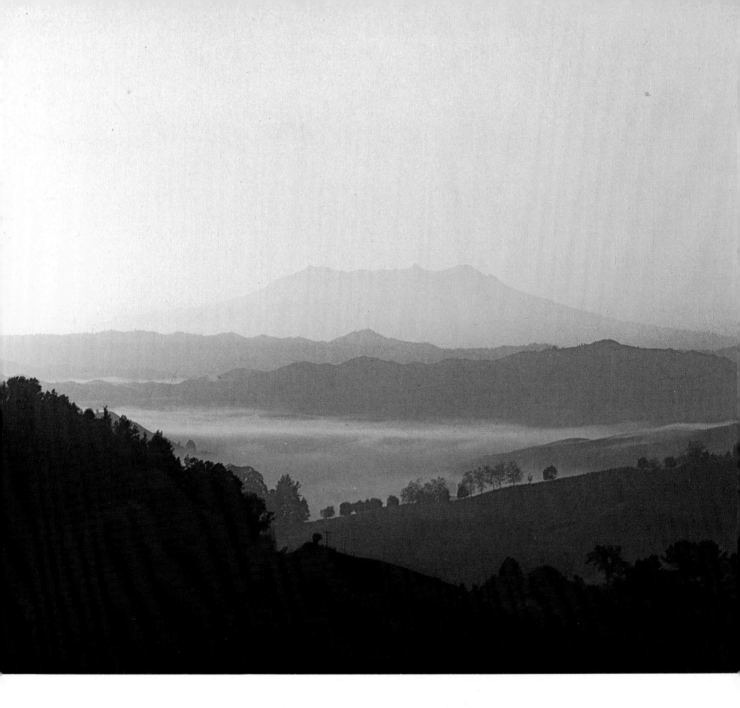

Above

Tongariro dominates the landscape around Hikumutu. Dwarfing the rumpled ranges at its feet, it stands 1,968 metres high against the sky, brooding in the misty haze of early morning over the fog-filled valleys, like some enchanted peak, effulgent and golden.

Right

Mount Egmont's heavily forested slopes provide bush walks and visits of extraordinary beauty. One Maori name for the mountain, usually given by distant tribes, was, simply, Pukehaupapa, which means "snow-covered hill." Their more common name for it, however, was Taranaki, a name now applied to the entire surrounding province. Taranaki means "a treeless mountain", indicating that it was a bare, erupting cone within the last 600 years. In lush rain forest like this, it is difficult to imagine.

46

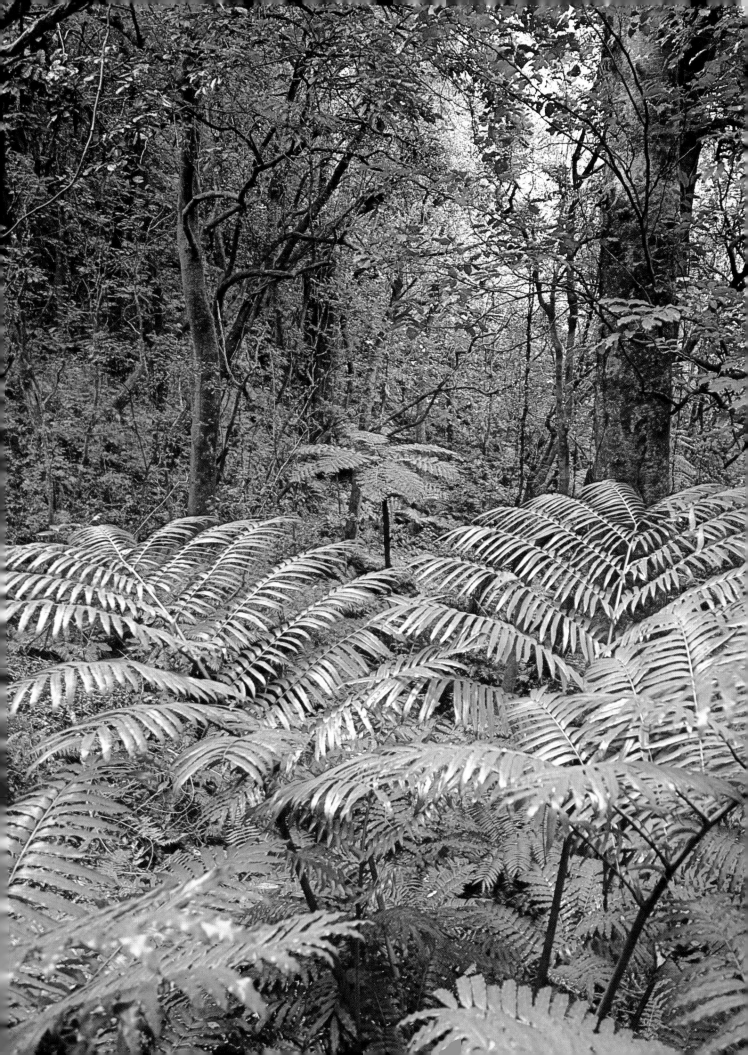

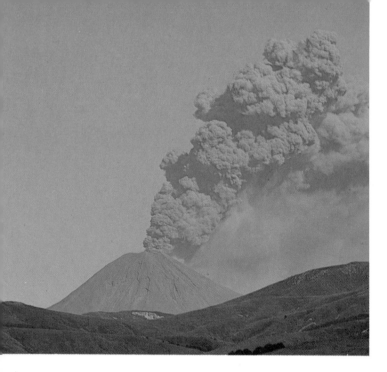

Above

Mt. Ngauruhoe, Tongariro's Siamese twin, linked to it by a tangle of minor craters, awesome, sulphurous pits and spurting fumerols, is still very active, still uncertain-tempered, prone to soiling its own and its neighbours' snowy mantles with dirty grey ash. Much of the surrounding countryside is endowed by the volcanoes with a poor, pumice soil which, however, has been brought by men's efforts and skill into a state of rich productivity.

Right

The Tongariro River, rising on that mountain's flanks, is a trout stream of world-wide fame. To it come anglers of many nationalities, to fish its often swift and rapid-ruffled reaches. Other rivers flow through more spectacular or more beautiful country. The Tongariro clatters down to Lake Taupo through a scruffy countryside of scrub and pumice, to split into a delta of five mouths before entering the lake.

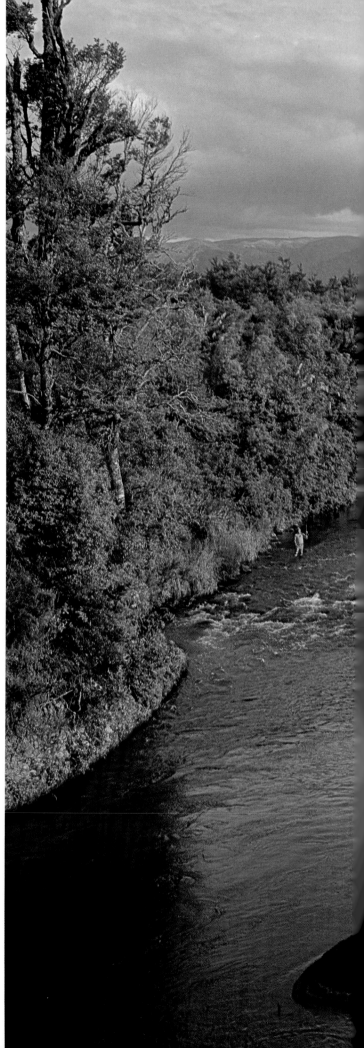

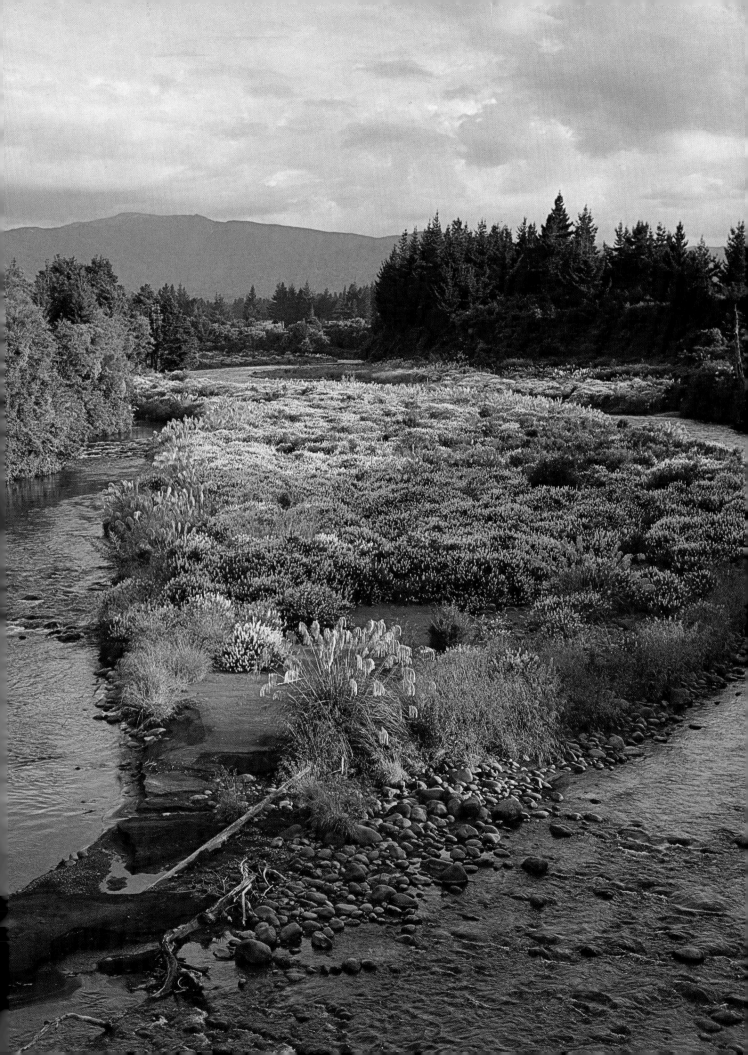

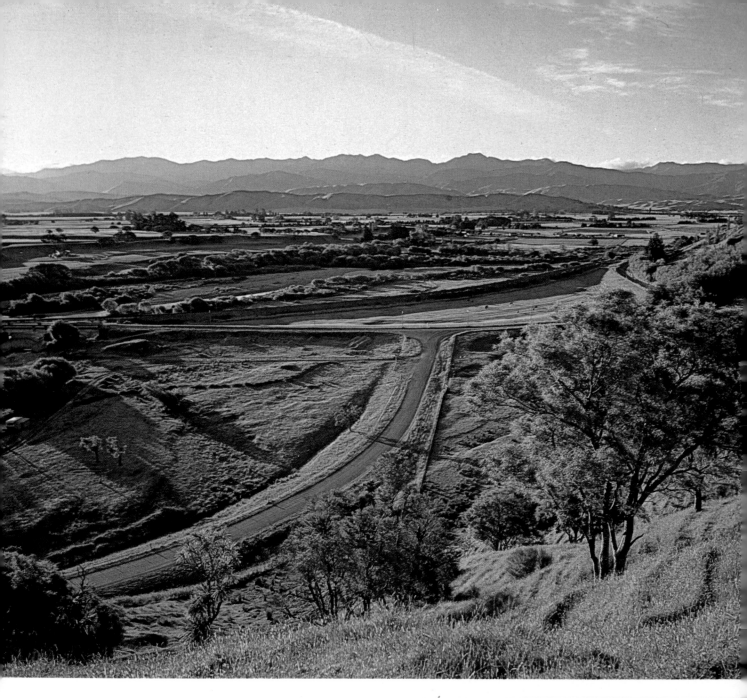

Above

The twisting Ruamahanga River flows down from the north-eastern slopes of the Tararua Range, sidling around the foot of the Wairarapa Hills and through the broad, fertile river valleys, to spill into Lake Wairarapa. It flows out of the lake again at its southern extremity, its pace barely modified, to enter Onoke Lake, the broad estuary at the head of Palliser Bay.

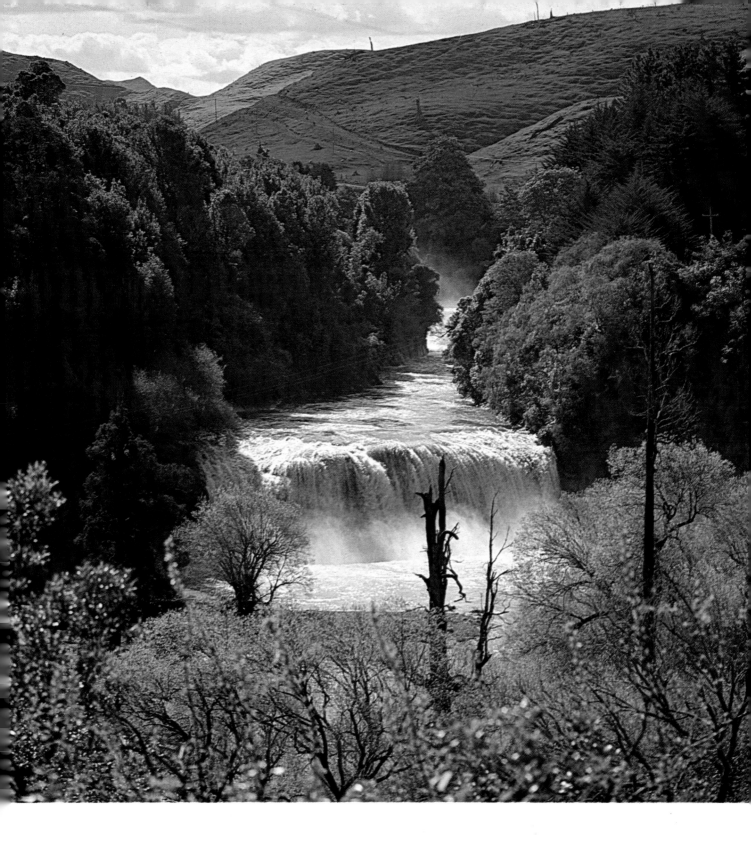

Left

At Omata, a few kilometres south-west of New Plymouth, is this rich grazing land, on a flattish shelf of land, backed by the foothills of Mount Egmont and falling away in gully-riven laterals to the sea, perhaps a kilometre away. High rainfall on this Tasman Sea coast, ringed in as it is by high ranges, makes for lush, green pastures and excellent dairy country. Taranaki abounds in cheese and butter factories, and some very fine cheeses are produced in and exported from this area.

Above

The Mangawhero River, rushing spectacularly between confining, bush-browed bluffs, and crashing down over a rock shelf, is seen here from the highway which runs between Wanganui and Raetihi through the Parapara Gorge. The country is hilly and broken, and watered by many streams like the Mangawhero, which itself is a tributary of the Wangaehu River.

Ice, Rocks and Water . . .

If I were asked to select a region of New Zealand where the quality of the sight-seeing was not adversely affected by climatic vagary, I would suggest an area which begins at Golden Bay in the north of the South Island, takes in the Marlborough Sounds, the east coast as far south as Kaikoura, and the West Coast for as far south as one can drive.

The reason for this odd selection would be that there are certain kinds of scenery which range from the sublimely, calmly beautiful to the grand and awe-inspiring, regardless of weather conditions, and that this area possesses them in superlative measure.

Golden Bay landscapes are enchanting, their elusive, always peaceful beauty changing subtly with the shifting daylight, or dramatically with the weather's moods.

The Marlborough Sounds are open, honest and cleanly blue when the sun shines on those magnificent waterways, or wild and wintry and mysterious when the water is dull grey-green and the clouds tear themselves to tatters on the forested tops that brood over the secret bays.

The Kaikoura Coast is stern and rock-bound, even menacing, when the easterlies send the long Pacific rollers smashing over the reefs, and the mountains, whose feet are washed by the raging water, lean back, white and majestic and inhospitable against the sky. When the days are calm and the sun shines, the pools and guts in the jagged reefs sparkle happily, yet always with a hint of menace in the oily stirring of the kelp beneath the heaving surface of the water.

The West Coast is all wild and lonely beaches, close beneath the mountains; swift, short rivers that can flood with savage power, and shining rivers of ice sliding inexorably down from the neves high in the Southern Alps into rain forests of almost tropical luxuriance; and smiling bays protected from intrusion by massive cliffs, where seals bask in the sunshine, and where the water becomes a mad maelstrom when the storms drive in from the Tasman Sea.

When does such a coast look its best? How can one ever say that one has seen it at its very best, when one has seen it in only one or two of its many moods? Mountain walls are grand, whether they reach up into the azure sky, or brood in tearing cloud. Great glaciers are all spangled and brilliant in sunlight, with turquoise shading and depths; and they are startlingly, luminously white beneath the lowering clouds, and their valleys are filled with a pure light that is noticeable from a distance, even before the glacier itself comes into view.

Other areas that delight the eye in sunshine look drab and miserable in rain. But not these regions. Their beauty is of that paradoxical kind that is constant in change.

Right
Lake Paringa is a bush-girt gem, much favoured by fishermen, who catch trout and salmon of respectable size in it. The name probably means "Flowing Tide", which is perfectly descriptive of the little lake, scarcely wider than its inlet and outlet stream. In times of flood, it does indeed seem to flow.

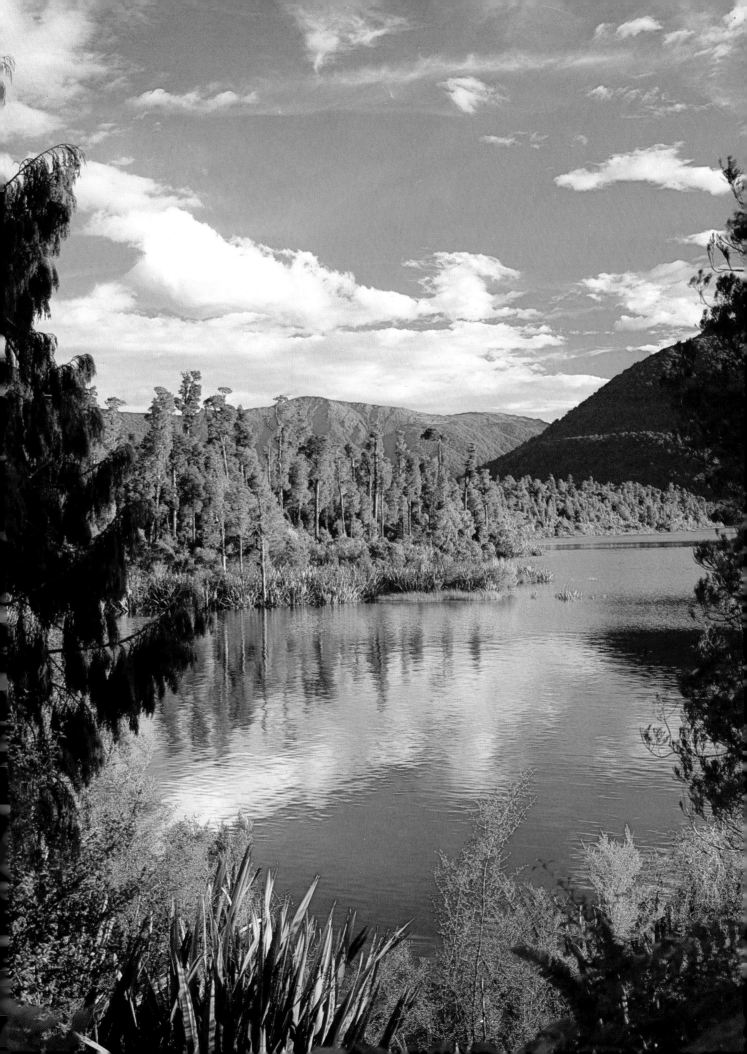

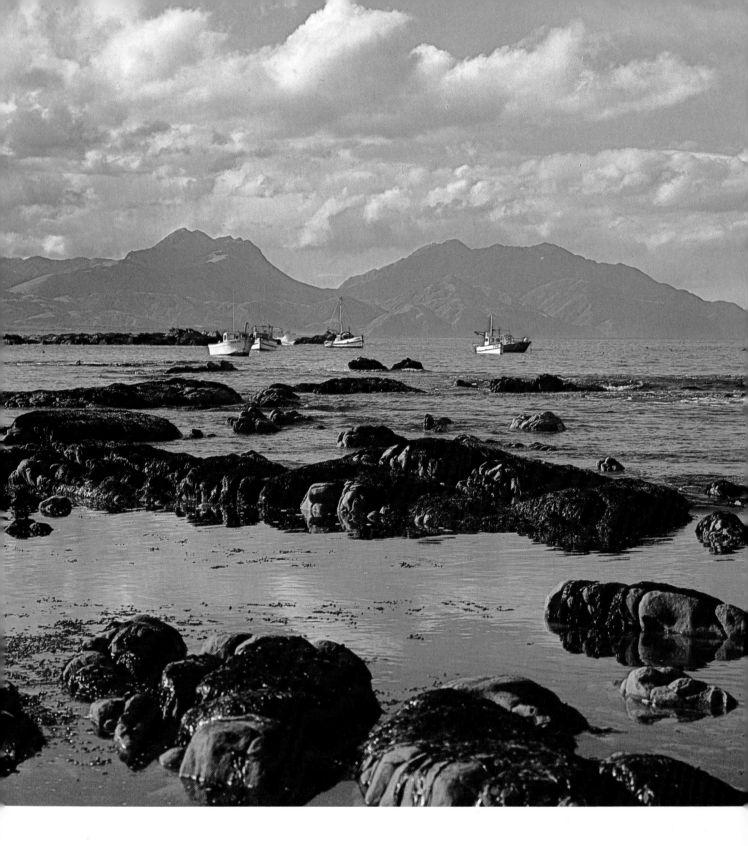

Above

The Kaikoura Peninsula thrusts out into the sea almost at the foot of the Seaward Kaikoura Range. Its off-shore waters abound in fish, for which reason Kaikoura harbours a seal colony which competes with local fishermen for food. Whales are sometimes seen blowing just off the coast, and crayfish abound along this rock-bound shore.

Right

Takaka Valley, spreading away from the feet of that marble mountain, Takaka Hill, is a captivating area of slow, meandering streams and tree-shaded meadows. The clear ocean light lends a special quality or depth to the colourings and shadings, which change subtly as the day wears on. But even beneath lowering skies and in rain, there's a sort of quietly brooding feel to the valley which lends an enchantment all of its own.

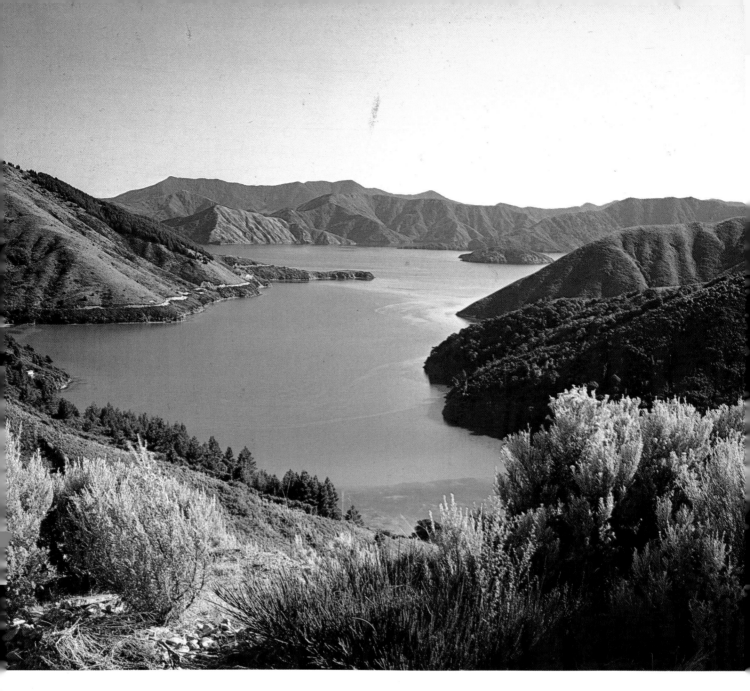

Above

Whatamango Bay in Queen Charlotte Sound is typical of the almost landlocked waters in this system of ancient drowned valleys. Aeons ago, the two main islands were one, but some cataclysm caused a massive subsidence, and that part of the land between Taranaki and northern Marlborough disappeared beneath the sea, which rushed in to fill the forested complex of valleys, and formed the Marlborough Sounds.

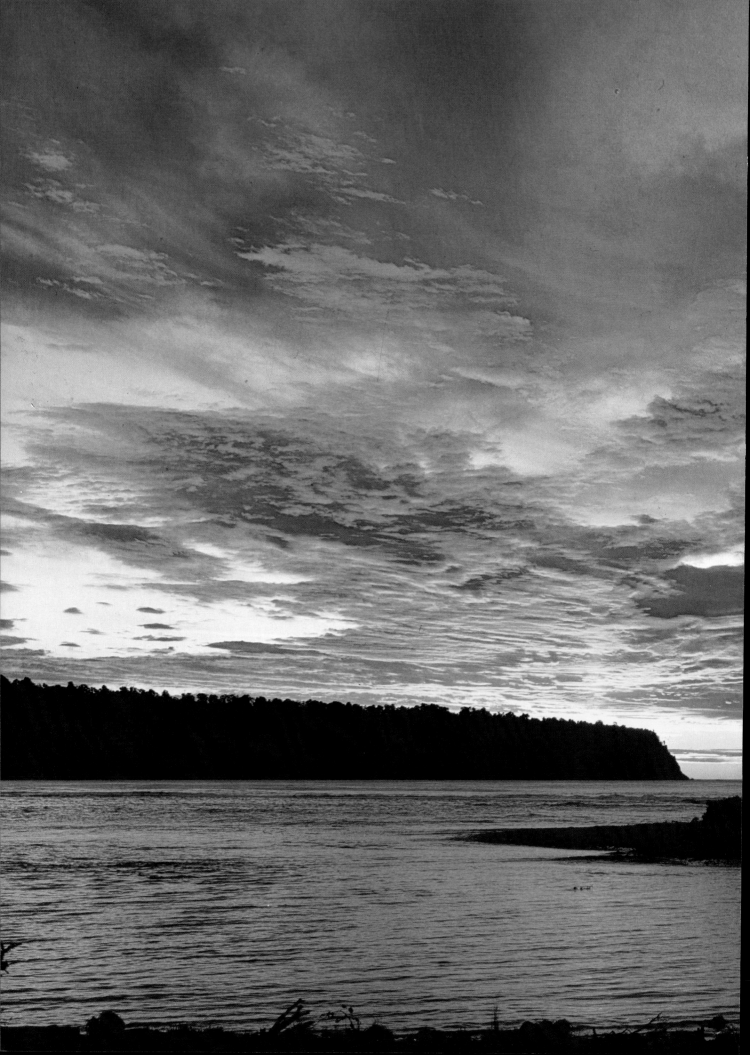

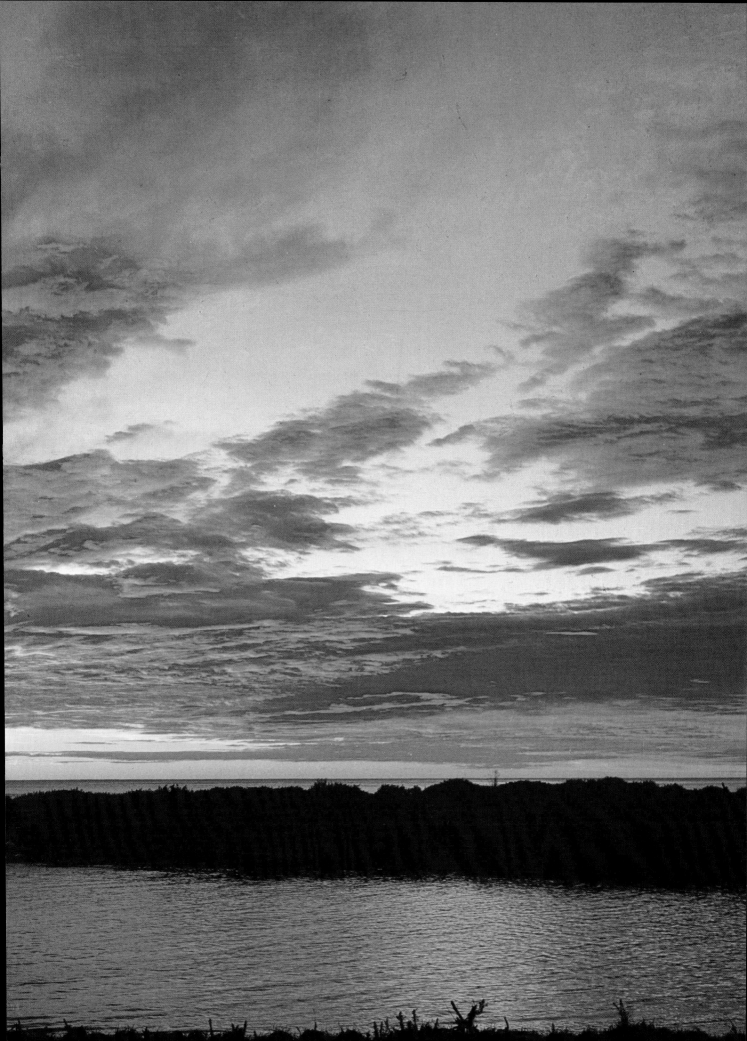

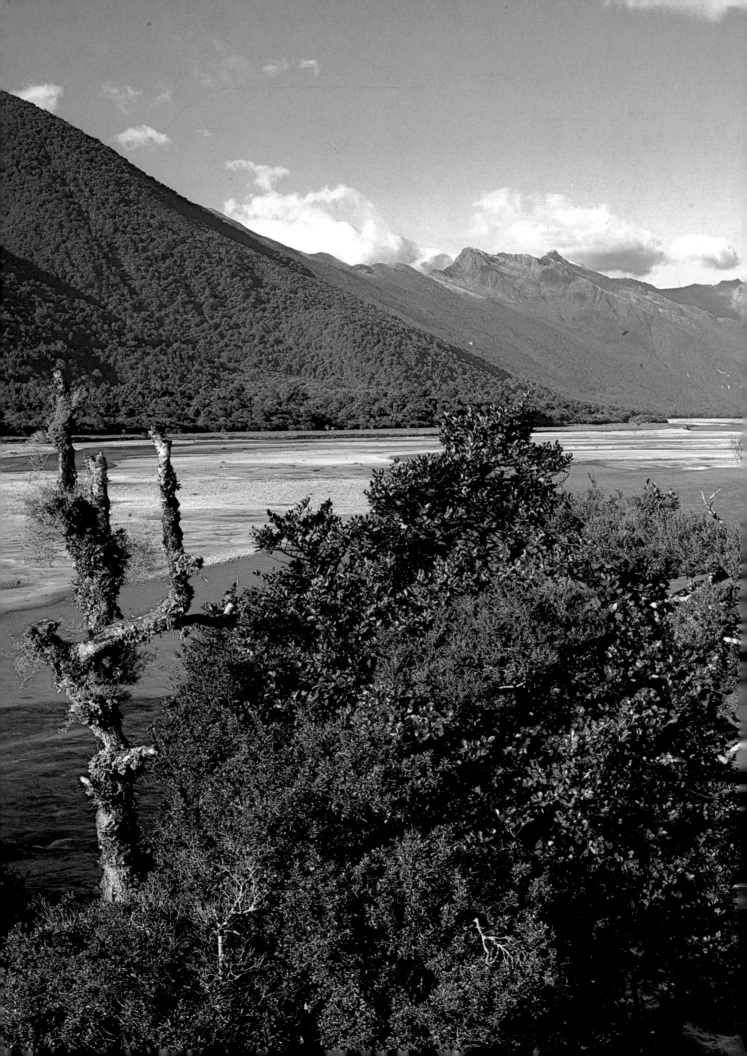

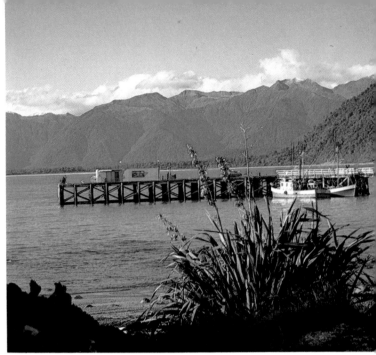

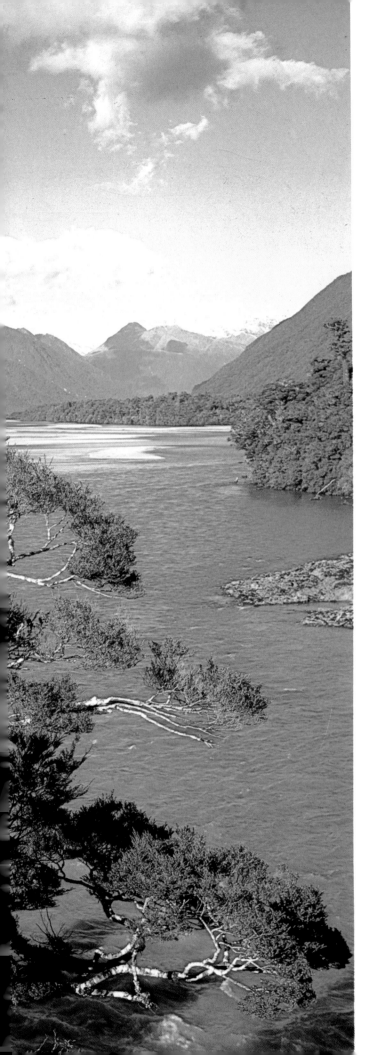

Above

Jackson Bay is a small inlet tucked away within the curve of a headland at the southern extremity of the Westland Bight. A minor port, with its small jetty, serving a timber milling and cattle-raising district, it is spectacularly lonely, hemmed in by forest and mountain.

Left

The Arawata River ranges down to the Tasman Sea from the Barrier Range, sweeping with it vast amounts of gravel from the crumbling mountains, spreading its burden across river flats and into forests, where the gravel chokes out the kahikatea trees and buries the undergrowth.

Previous Page

Bruce Bay is a lonely, forsaken place, though a moderately busy highway speeds past it mere yards away, screened from it by a fringe of bush. About halfway between Fox Glacier and Haast, battered by furious Tasman Sea gales and littered with driftwood it possesses a sort of forlorn beauty which can be haunting when you view a glorious Tasman Sea sunset from its gravelly strand.

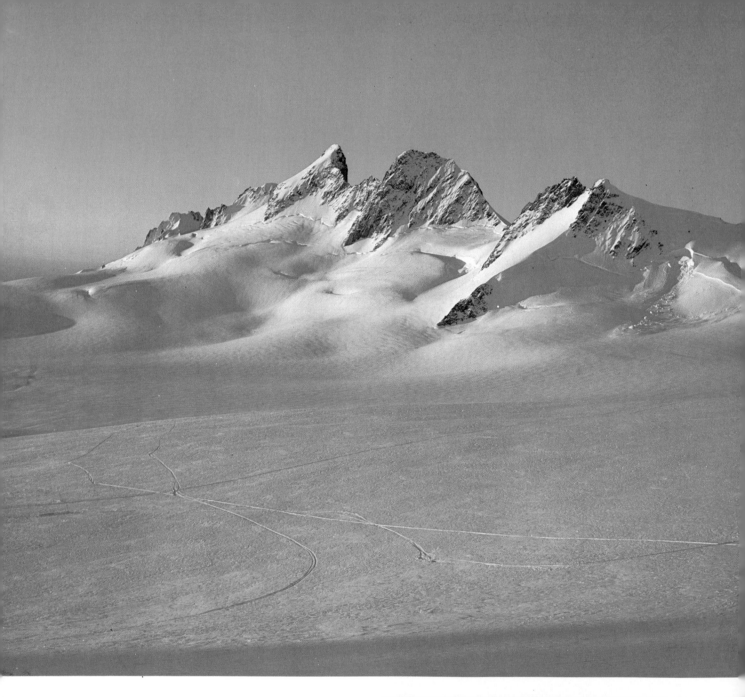

Above

Fox Glacier slides down from a vast snowfield between the Fritz and Fox Ranges, about 5km north of Mount Cook. It crushes itself into a narrow passage between Chancellor and Paschendaele Ridges and bulldozes its way a further twelve or thirteen kilometres between towering rock walls, to terminate in a valley surrounded by rain forest.

Right

Westland's fierce little streams rush down from the mountain heights to the sea through scenes of magnificence and great beauty. This is typical South Westland scenery — the stream, quiet enough along this reach, clattering over shallows before a backdrop of darkly green forest asterisked with giant tree ferns.

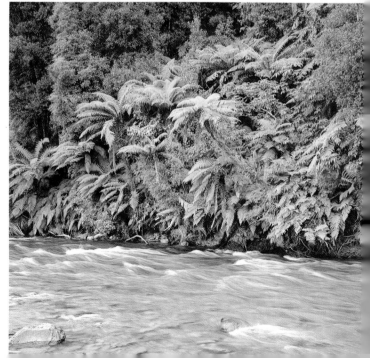

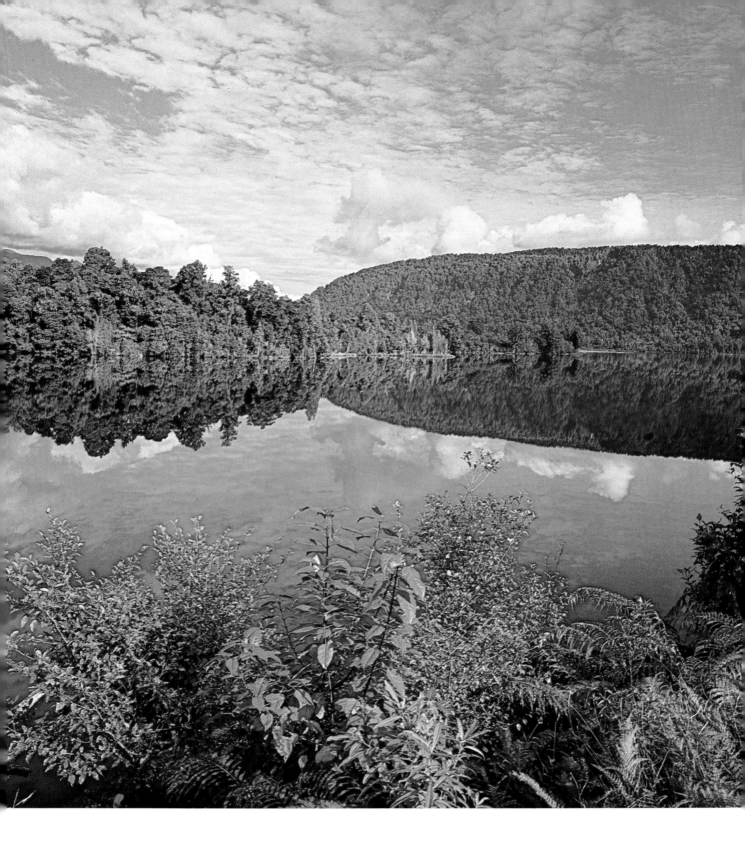

Above

Lake Mapourika is a glacial remnant, a one-time piece of "dead" ice about 40 metres thick, now melted to form a peaceful, forest-fringed water of great beauty, famed for its reflections of the great peaks surrounding Franz Josef Glacier. It was named by goldminers, after a ship which plied between Australia and the West Coast.

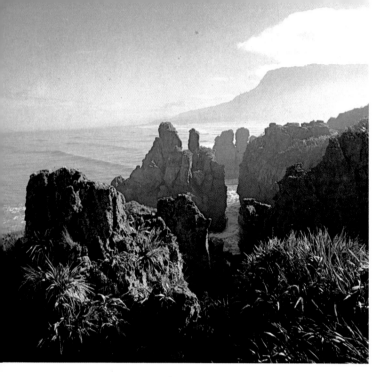

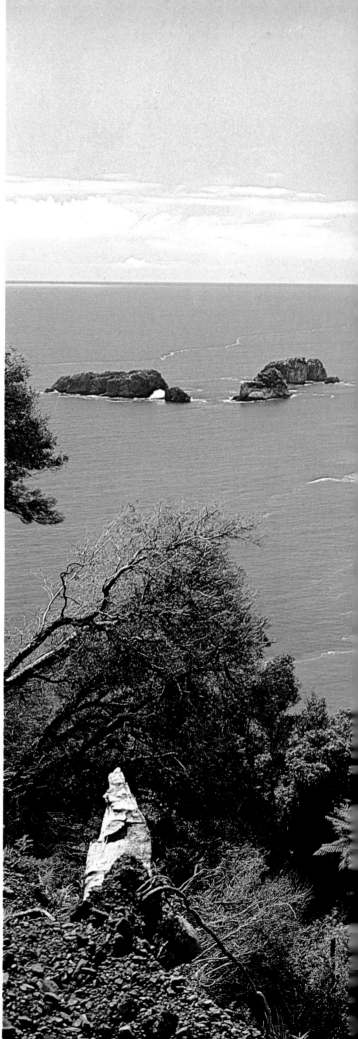

Above

Punakaiki, home of the celebrated Pancake Rocks, is swept by a warm ocean current which makes the hinterland an area of beautiful rain forest, and allows the nikau palm to grow prolifically, so that the area has the appearance of some tropical island shore.

Right

Knights Point was named for the fancied resemblance to the head of a black Labrador retriever belonging to one of the surveyors of the Haast Pass route. The beach is inviting, though difficult of access, which makes it an almost perfect sanctuary for the seals which bask on it, and on the offshore rocks.

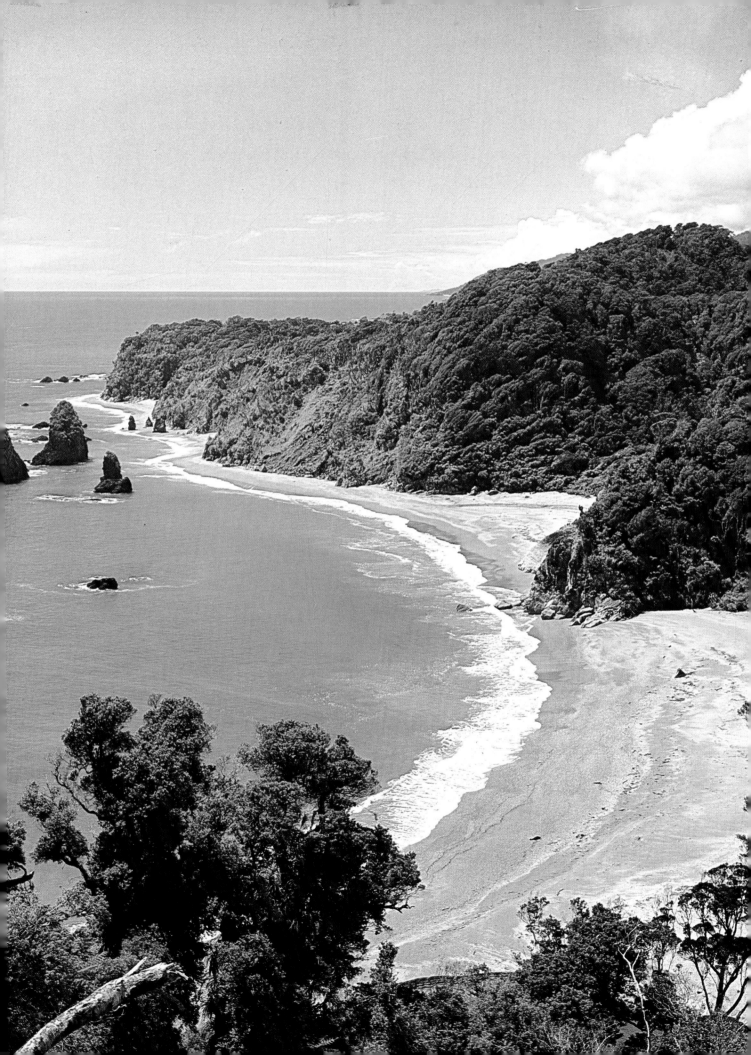

A Land For All Seasons . . .

Often, when one speaks of Canterbury and the regions between the Hurunui River and the Waitaki River, the listener forms a mental picture of a vast, patchwork flat-land in shades of khaki, bounded to the north and south by dun-coloured hills, and to the west by the mighty massif which builds up to the Southern Alps.

It is a picture which contains a modicum of truth — which is to say that at the height of a dry summer, that's about how it looks, at least from the air.

But there's much more — oh very much more — to Canterbury than that.

If the northern portions of the North Island can be fairly called a Summer Land, Canterbury could well be described as a Land For All Seasons.

Spring, in my opinion, is the season when Canterbury is at its very best. Summers tend to be dusty and hot, on the plains. Autumn is mellowly kind, regretfully yellowing the leaves of the deciduous English trees and making amends in the more open woodlands with a profusion of giant red toadstools, white spotted, like the ones in a childs-fairy-story book, and in the open fields with rings of white, edible mushrooms which push up from the still warm earth at the invitation of misty, soft autumn rains. Winters can be cruelly cold; not the clean, dry, impersonal refrigerating of Otago and the Canterbury highlands, but a sneaking, insinuating, dank, miserably personal chill, especially in the plains. But in spring, all is fresh with pale, new greenery, and snowdrops and daffodils nod, and bees begin to appear amongst the flowers and the jewelled buds of morning.

In spring, the hills are brightly green, with the paler green of newly verdant willows and oaks and elms to counter the drab strokes of the pine and macrocarpa shelter belts which are written across the land. The plains are still a patchwork, but it's a predominantly green patchwork, with the browns and brown-greys of spring ploughing in the rich, alluvial soils or the self-fertilised limestone hills. Spring softens the harsh Mackenzie Country. Spring blesses the towns and the country gardens and orchards with blossom.

Of course, Canterbury has its attractions in winter, summer and autumn, too. Nowhere are you more than a couple of hours' drive away from excellent winter skiing. The snow covers the high hills of the back-country, refrigerating the night air, encouraging crackling frosts which freeze the upland lakelets, obliging the skaters who swarm out from the towns for a day's sport.

And in summer, there are vast sweeps of golden-sand beach, gravelly, clean rivers with numberless deep swimming holes , and boating and fishing lakes. There are golden, sheltered bays, drowsy, pleasant little towns, cool bush and rugged mountain faces which beg to be climbed. There are breezy downs for gliding, and flat obstacle-free airfields with miles of unencumbered airspace.

Canterbury is a place of orderly towns, well-planned because there was time to plan them in an island mercifully free of wars. And, of course, because much of Canterbury is billard-table flat, its largest city and at least one of its principal towns could be laid out at leisure on English drawing boards, and the plan transferred to the actual site with little or no alteration. Therefore, Canterbury towns have broad streets, tree-shaded avenues, quiet crescents, all dedicated to the proposition that an Englishman's home is his castle, and should be insulated from neighbouring castles by a decent width of lawn and garden.

Canterbury is pretty villages tucked into the folds of the rolling hills, or spread around delightful bays, or standing on a rocky coastal shelf, between towering mountain ranges and the furious, pounding sea.

Canterbury is pine shelter-belts, designed to dissipate the power of the rampaging nor'westers and thus save the topsoil from being hurled across the plains and out to sea in buff-coloured clouds.

Canterbury is crumbling gravel-heaps of mountains, rearing up from seas of gravel where tangled skeins of gravel-choked waterways find their way down to the sea. Canterbury is — Canterbury. In all seasons, it has a flavour and a feel all of its own.

Springtime is the time when the daffodils are bright in Hagley Park in Christchurch, and the

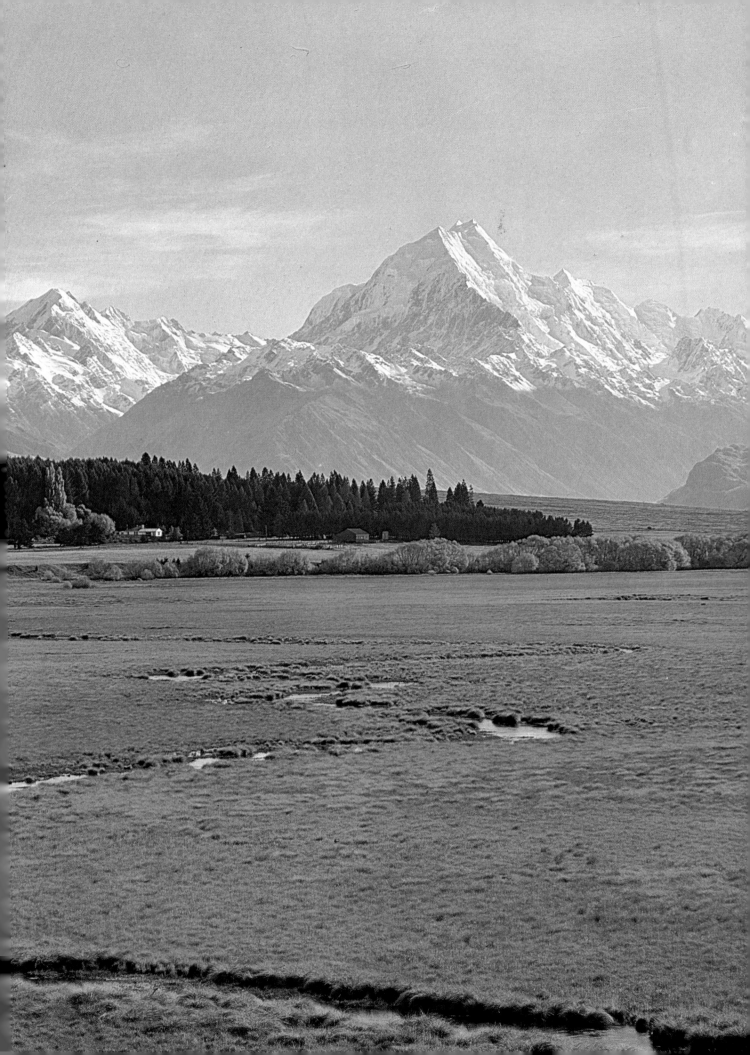

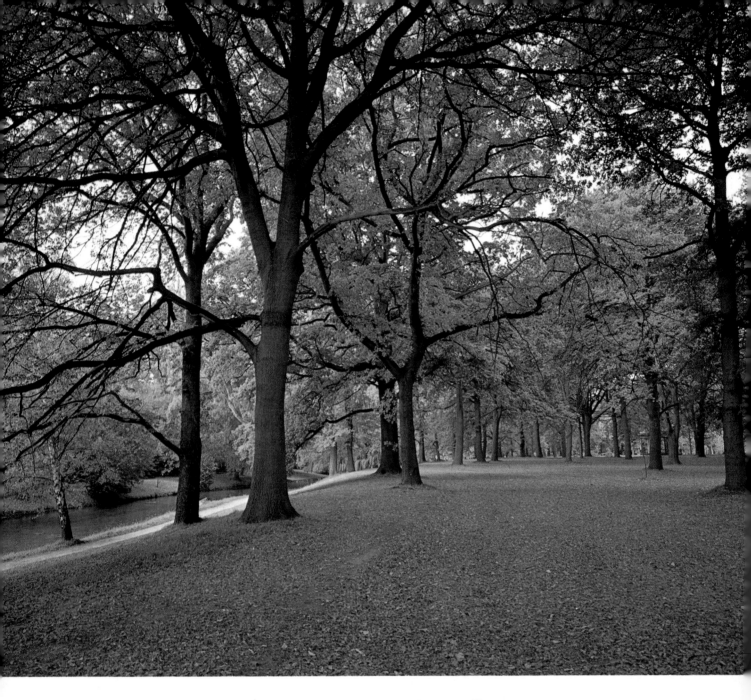

bluebells begin to appear amongst the trees in its northern end. Spring comes in diffidently, with a day or two of warm nor'westers and a new strength to the sun. Winter lashes back petulantly at it, and it is not unheard of to have snow in December or early October; but even when that happens, there is a new feel, a new resilience in the air.

In Canterbury, lambs begin to appear before July is past, and by the time that spring is firmly in the saddle, they are strong and frisky as spring lambs should be, and not the diffident, timorous little creatures who crept into the tail-end of a Canterbury winter.

Previous Page
Mount Cook's stupendous peak, soaring up 3,764 metres, and the entire, eternally snow-clad massif around it, is an everlasting reminder of winter to the runholders whose lands spread about its feet. Here, homesteads nestle for protection amid stands of pine, and draw about themselves a sprinkle of deciduous trees which turn yellow at the approach of winter, and are softly green when the days of harsh cold are passing and the promise of summer is in the air.

Above
Hagley Park, Christchurch's 248 hectares of playing fields, golf course, streams, Botanic Gardens, lakelets and some delightful woodlands is well known far beyond Christchurch. This stand of oaks and other English trees is bounded by the Wairarapa Stream, a tributary of the Avon. Starred with bluebells, daffodils and snowdrops in spring, and carpeted with leaves and dotted with giant red toadstools in autumn, it is a beautiful refuge from the noise and bustle of the surrounding city.

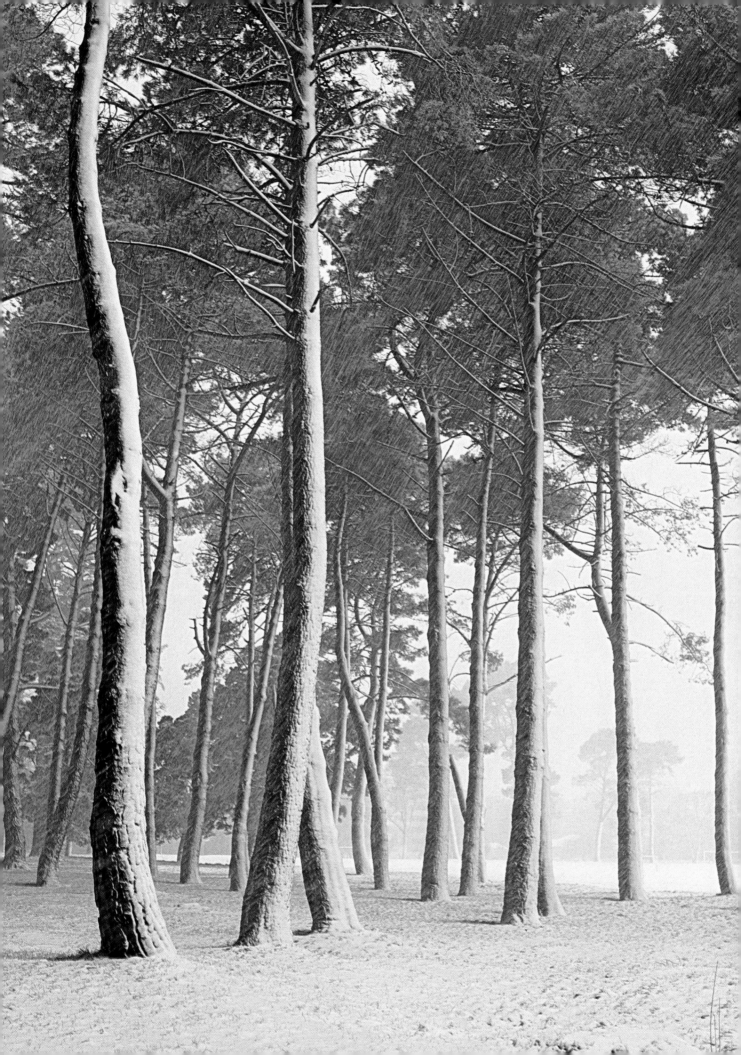

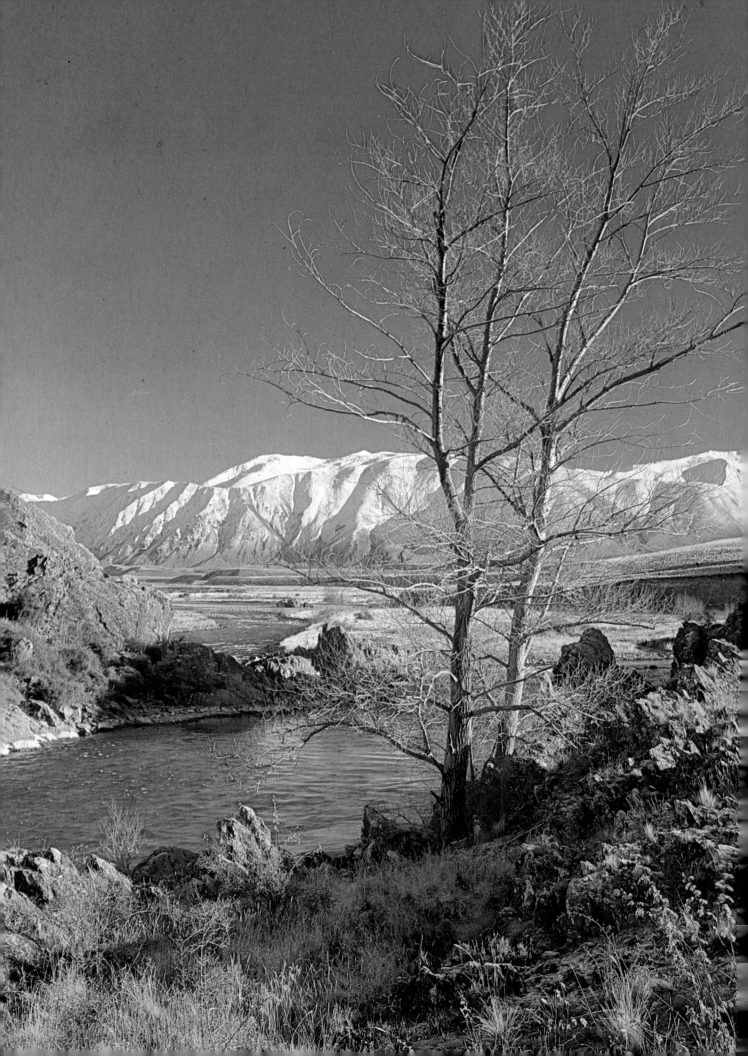

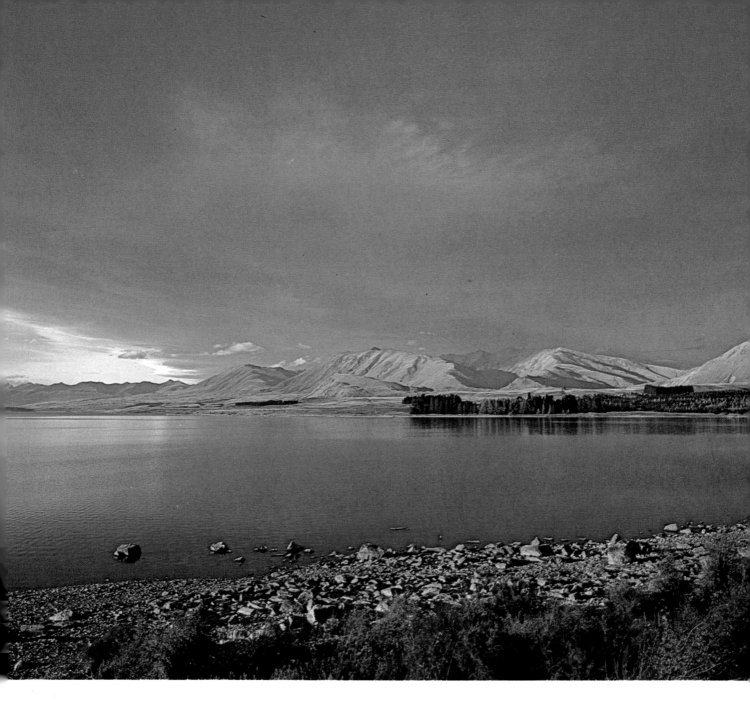

Left

The Ohau River drains Lake Ohau, a 23-square mile stretch of coldly placid water in the Mackenzie Basin. At an altitude of 523 metres above sea level, the surrounding country is harsh, a thin, dry soil and sparse snowgrass threadbarely clothing a rugged, rocky terrain.

Previous Page

In north Hagley Park, Christchurch, is this magnificent stand of pines, here shown plastered and carpeted with snow. Snow is infrequent on the coastal plains, but in most years, usually just about the time that everyone thinks winter is over, a fall occurs which is heavy enough to settle for a few hours.

Above

Lake Tekapo is wildly beautiful, a sort of upland loch, hidden in the Canterbury hinterland but belonging to the Scottish Highlands, with its piney, brambly, stony foreshore, its stone kirk on a desolute headland and its pine-crowned island. The bed of an ancient glacier, Tekapo is 25kms long and 5km wide. It is surrounded with splendid alpine scenery.

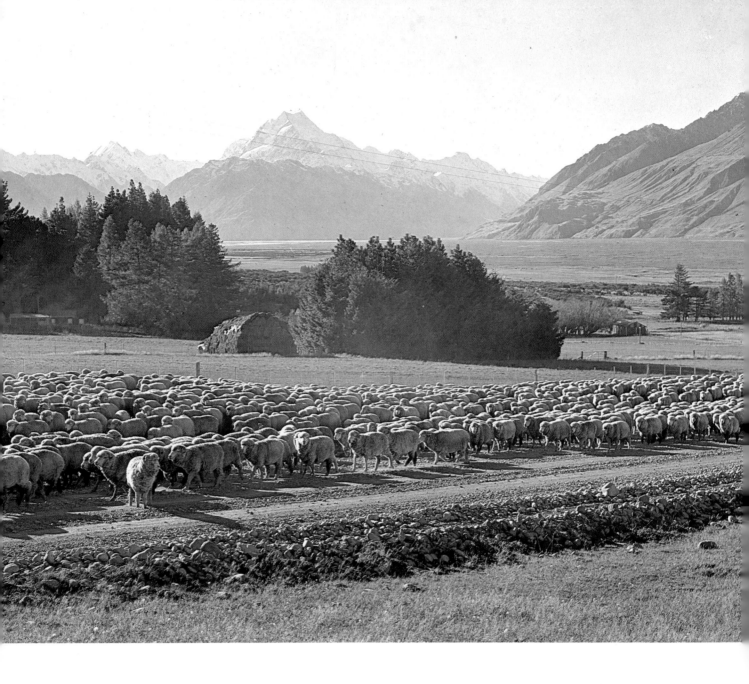

Above

Glentanner Station is a typical high-country sheep run. Sheep graze over the rock-ribbed peaks in summer, but must be mustered down to the flat in early autumn, before the winter snows cover the surrounding heights and make them inaccessible to shepherds and inhospitable even for the hardy Merino.

Right

The snows of the Southern Alps, plastering the vertical walls of the mountains, crack like weathered paint as the summer comes in and the thaw begins; and then the avalanches thunder down into the valleys. But the deep snow in the folds of the high ranges never disappears, but builds up year by year, to feed the mighty glaciers.

Over Page

Lake Pukaki, with Mount Cook towering above and perfectly reflected in it, is the second largest (31 square miles) of the Mackenzie Country lakes. Lying crooked in the frigid arm of the Ben Ohau Range, fed by the Tasman River, it is the site of major hydro-electric works.

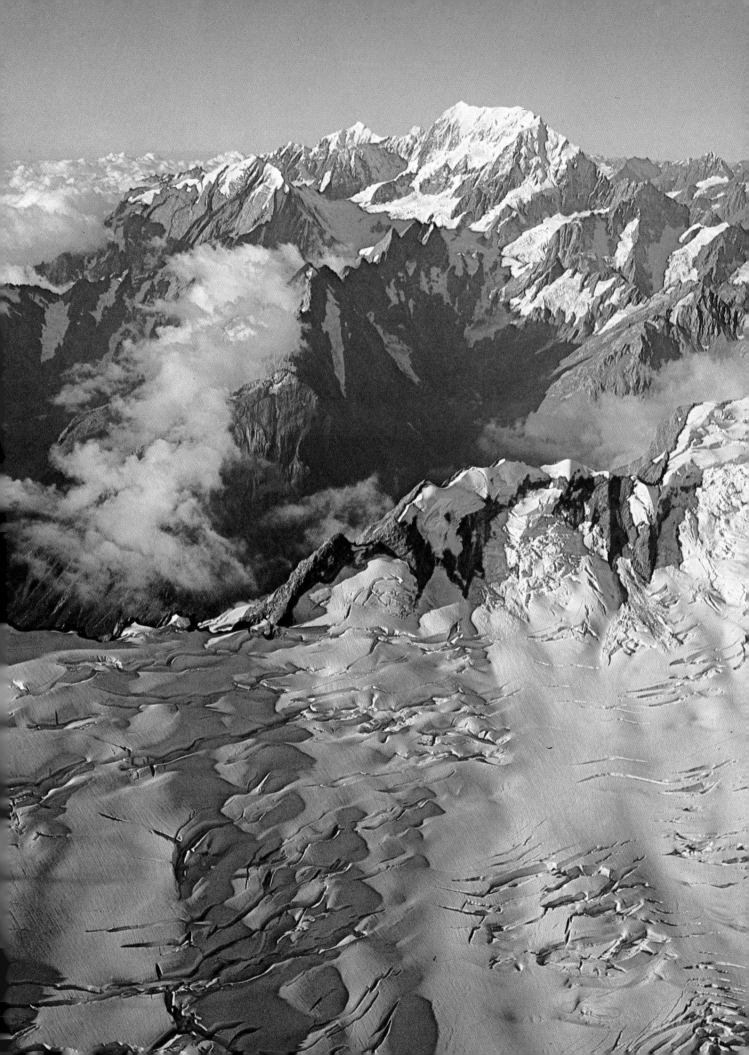

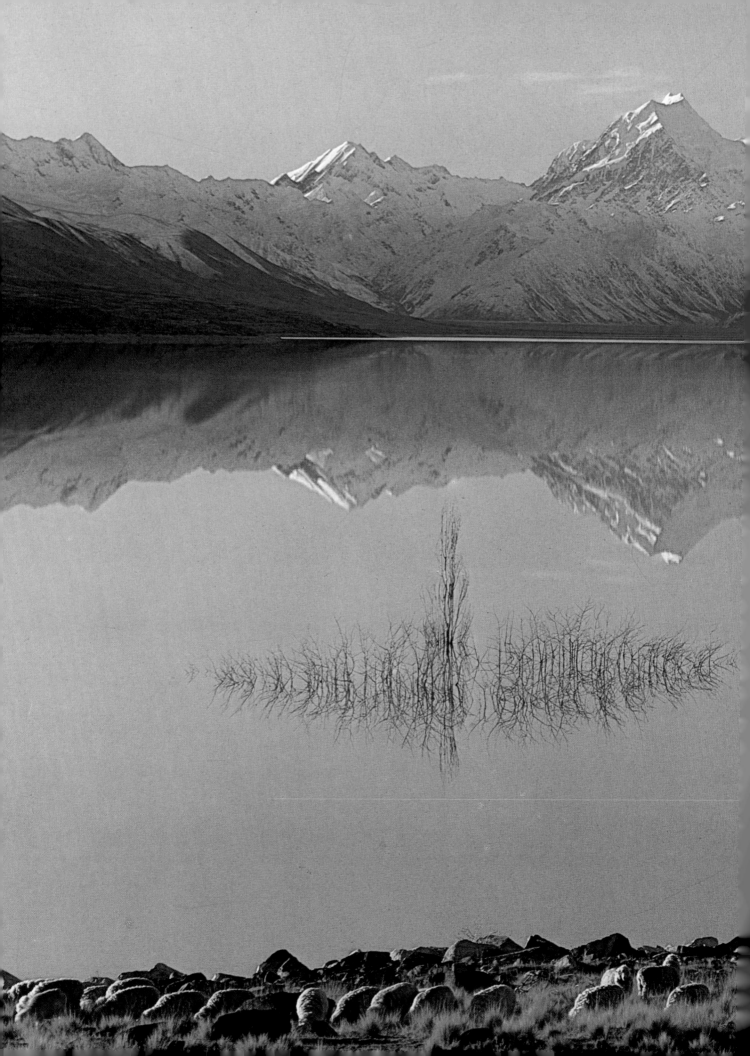

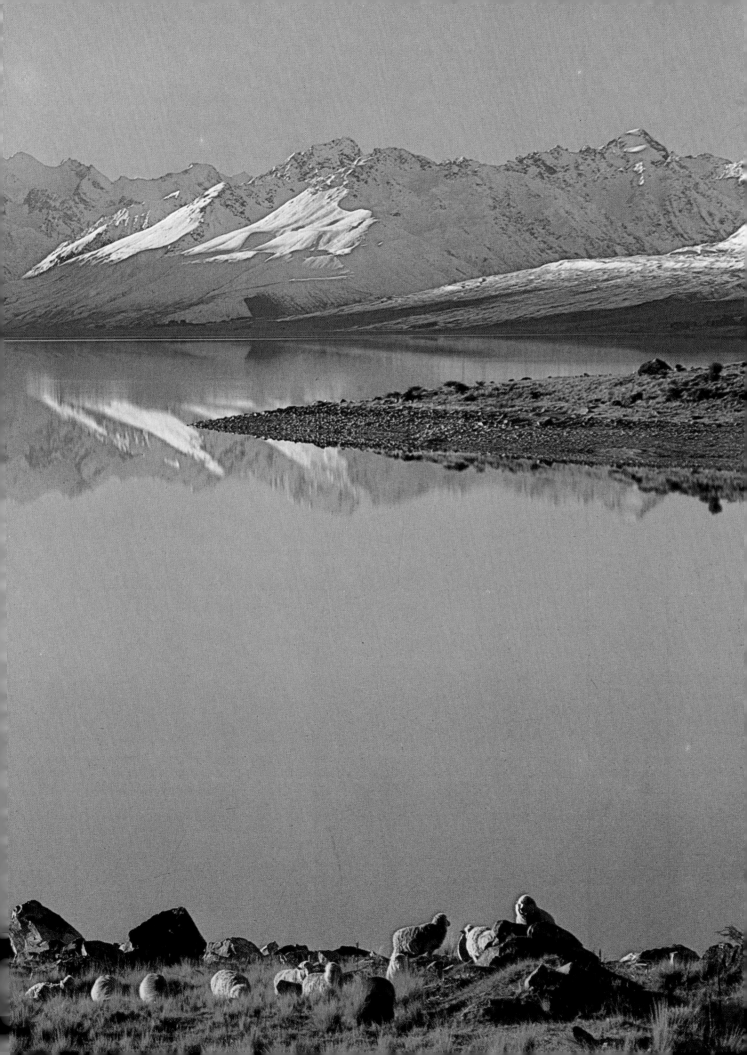

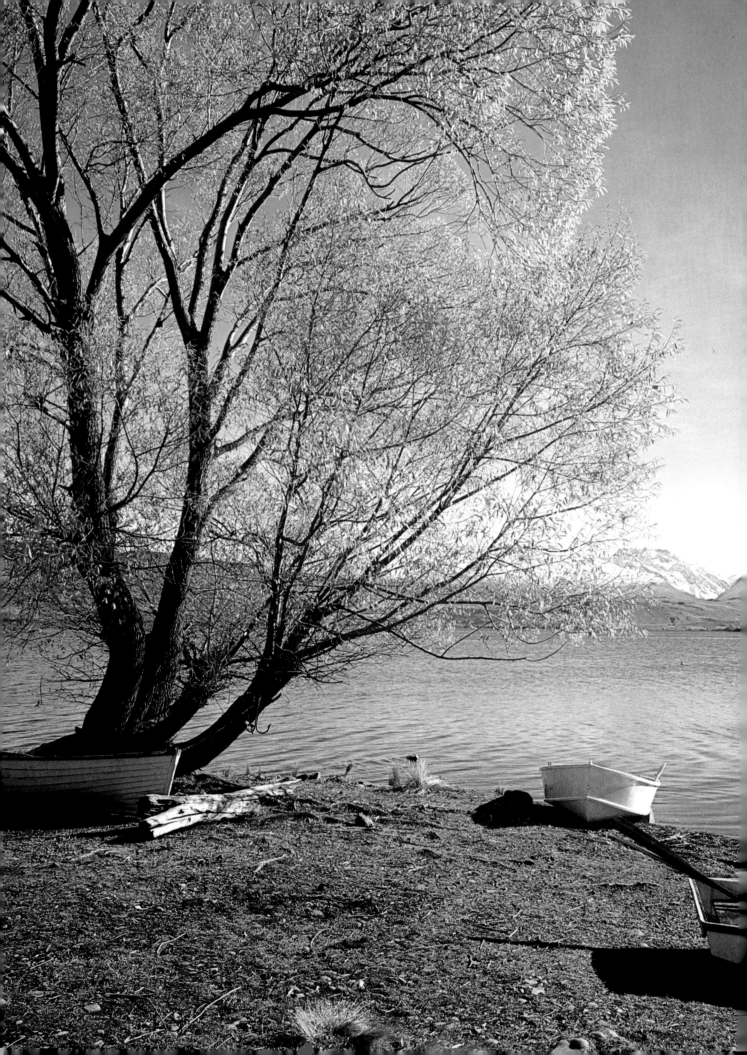

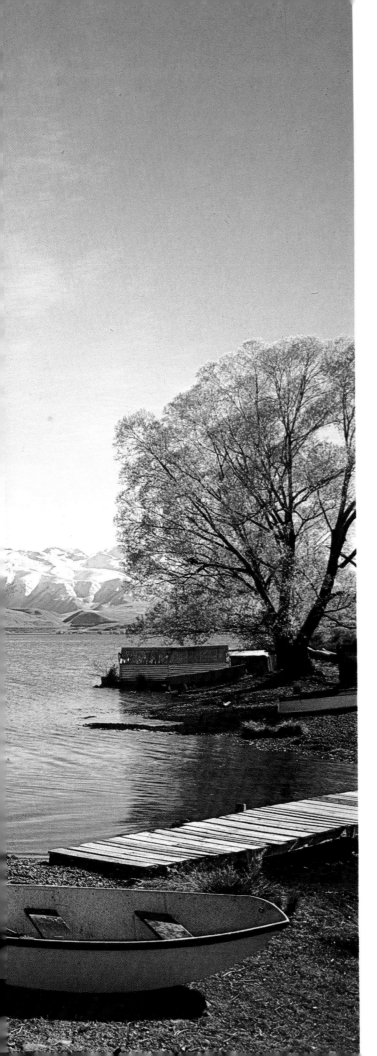

Left

Lake Alexandrina is less celebrated than Lake Tekapo, being its smaller neighbour and slightly off the main route; yet it has a placid beauty which makes it a favoured picnic spot, and it is greatly esteemed by anglers. The highland basin discovered by a Gaelic shepherd, James Mackenzie, is beautiful in a rugged and somewhat hostile fashion, but is scenically softened, here and there, by these delightful lakes.

Below

Lindis Pass, from the lakelands of Central Otago, winds through lonely valleys between hills like tawny camels' humps, to the southern extremity of the Mackenzie Basin. A place of burning heat in summer and quick floods in winter, it always manages to appear brown and dusty and, somehow, thirsty, with occasional oases of green willows clustered about the banks of the brawling meandering Lindis River.

Above

The Waipara River has carved its way through the limestone hills to Pegasus Bay, from its source in the North Canterbury hinterland. This gorge is in a country somewhat more rugged than the tidy farmlands nearby in the upland basin, but it is country which is still hospitable, still accessible and valuable for grazing. In contrast to the plains rivers, with their barely determinate boundaries, the Waipara's banks are sharply terraced, its course winding but singular, as it cuts its way around rocky bluffs, always seeking the line of least resistance.

Right

Harwarden, (pronounced Harden), is a hamlet in the North Canterbury upland basin, serving a farming community. The surrounding countryside is pretty, organised sort of country, with well-managed pasture, arrow-straight fences and neat farmhouses. This view is typical of the area, with its shade belts of pine and its streamlets bordered by willow and poplar; and always, as a backdrop, the surrounding walls of mountains and rugged hills.

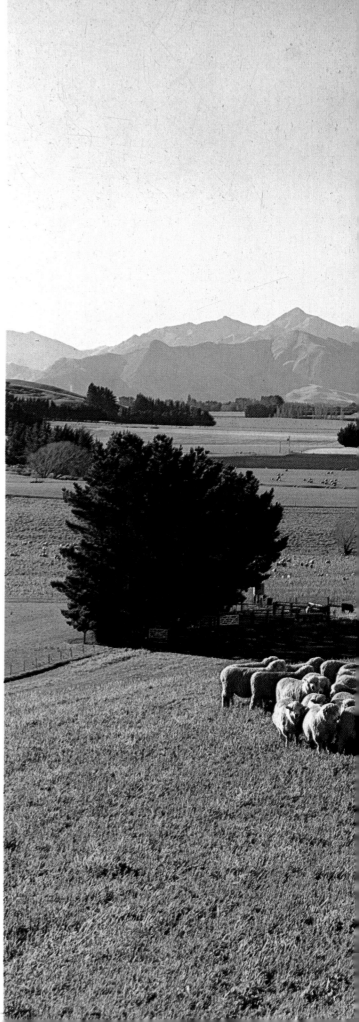

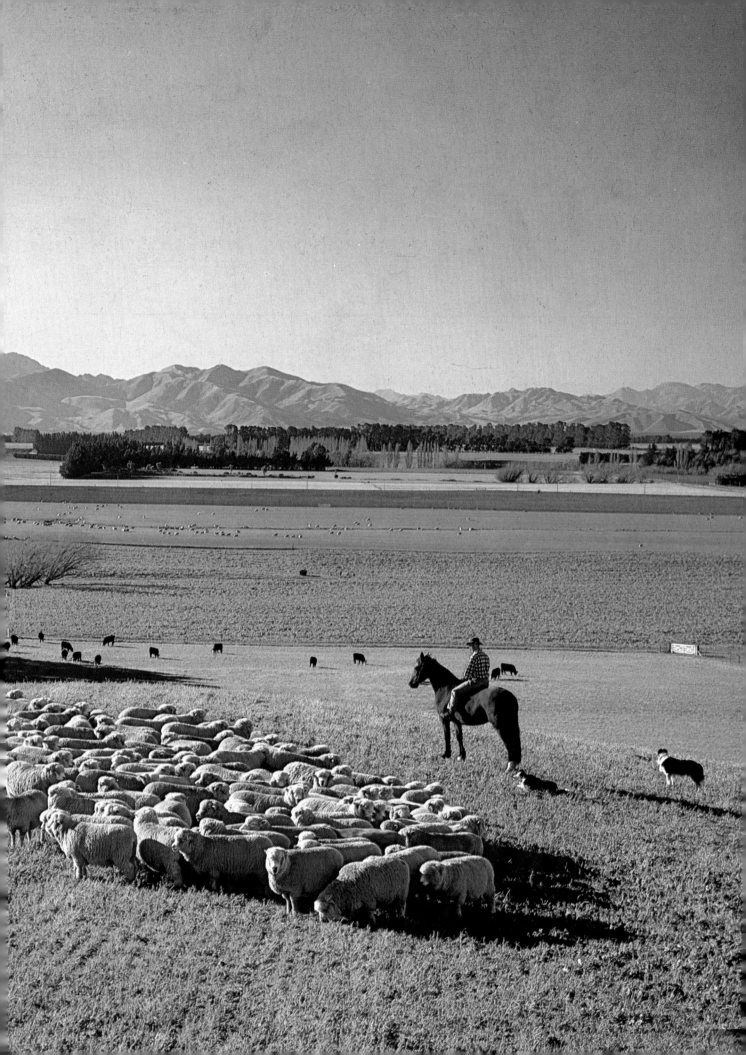

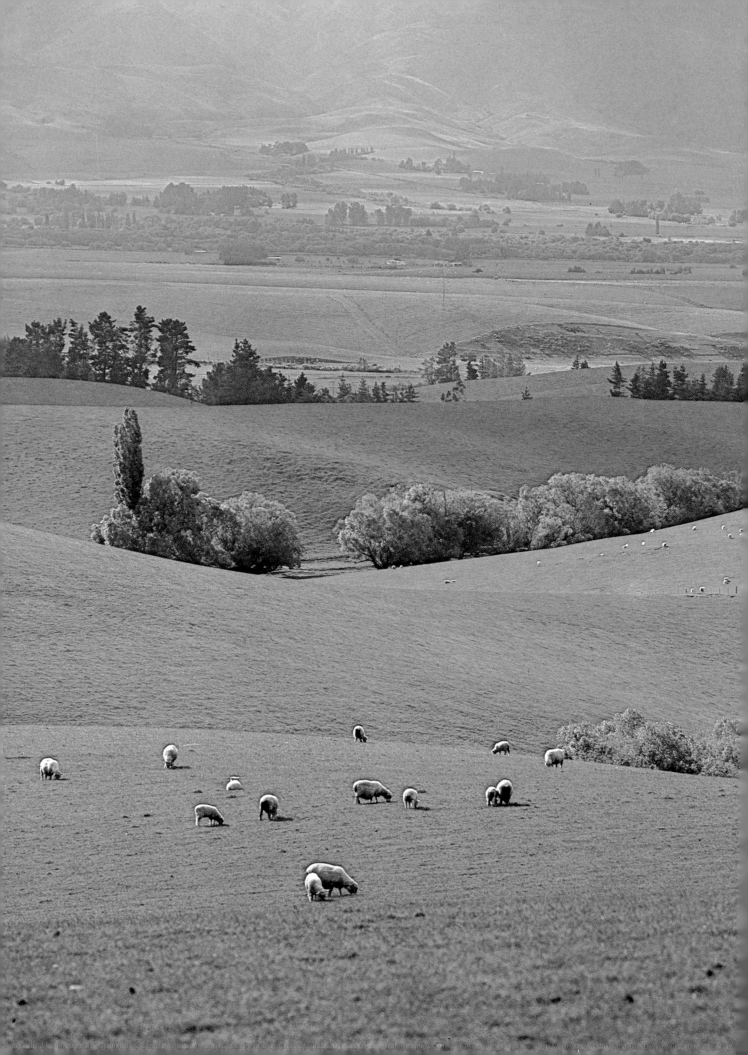

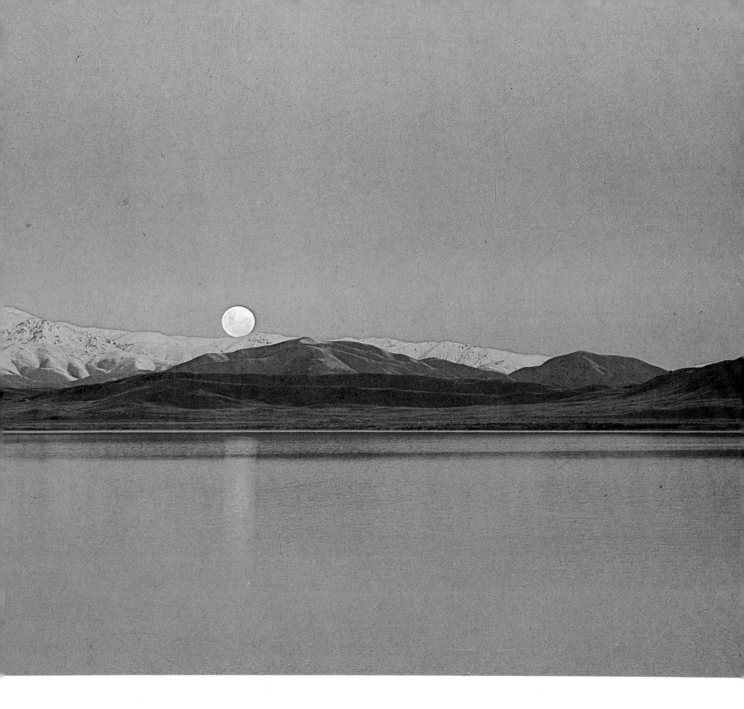

Above

Lake Pukaki is fed by the Tasman River, running milky and cold from the Hooker and Tasman Glaciers, past the foot of Mount Cook. At an altitude of 482 metres, it is skirted by the highway running to the Hermitage, Mount Cook. Its outflow is the Pukaki River, tributary of the great Waitaki.

Left

Fairlie nestles at the foot of the rugged hills behind which lies the Mackenzie Basin. It is an area marking a sort of transition from the wild, unkempt hills that form the basin's eastern wall, and the gentler, rolling pastures that go down to the flatlands.

Over Page

The State Forest at Balmoral stands geometrically square in this upland valley in North Canterbury. A place of rolling, limestone hills and terraced river flats casually dressed with willows and poplars, at Balmoral it is severely patched with the dark green of the State pine forest, where the trees are marshalled into armies, their ranks straight, with broad fire-brakes separating the regiments of radiata.

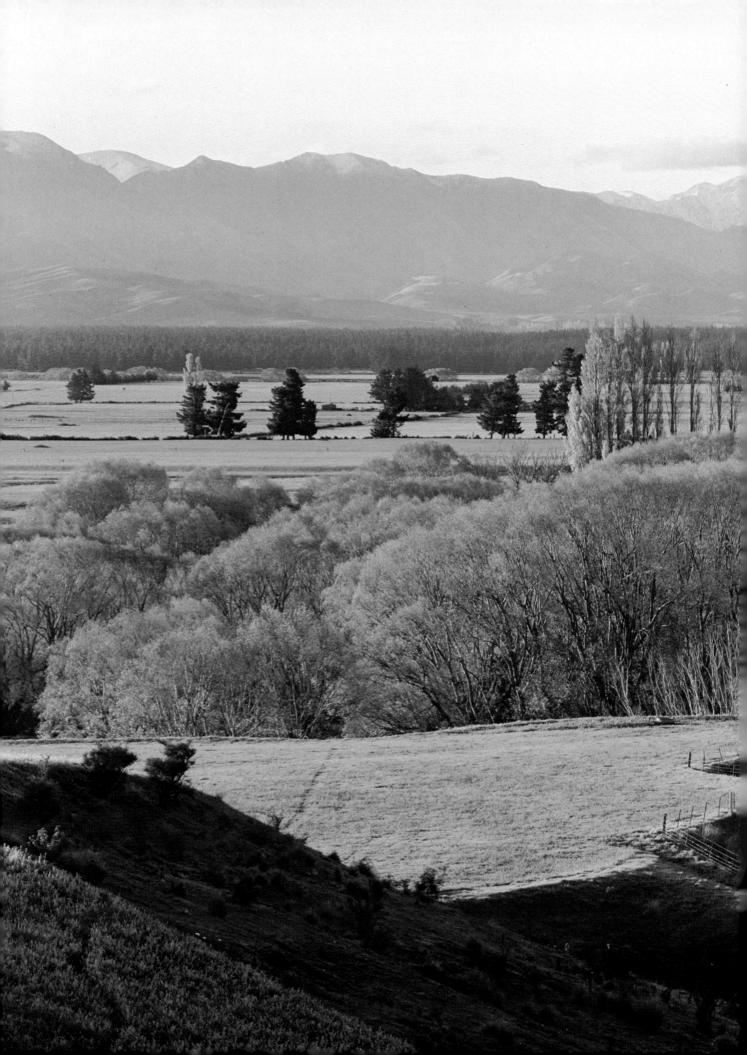

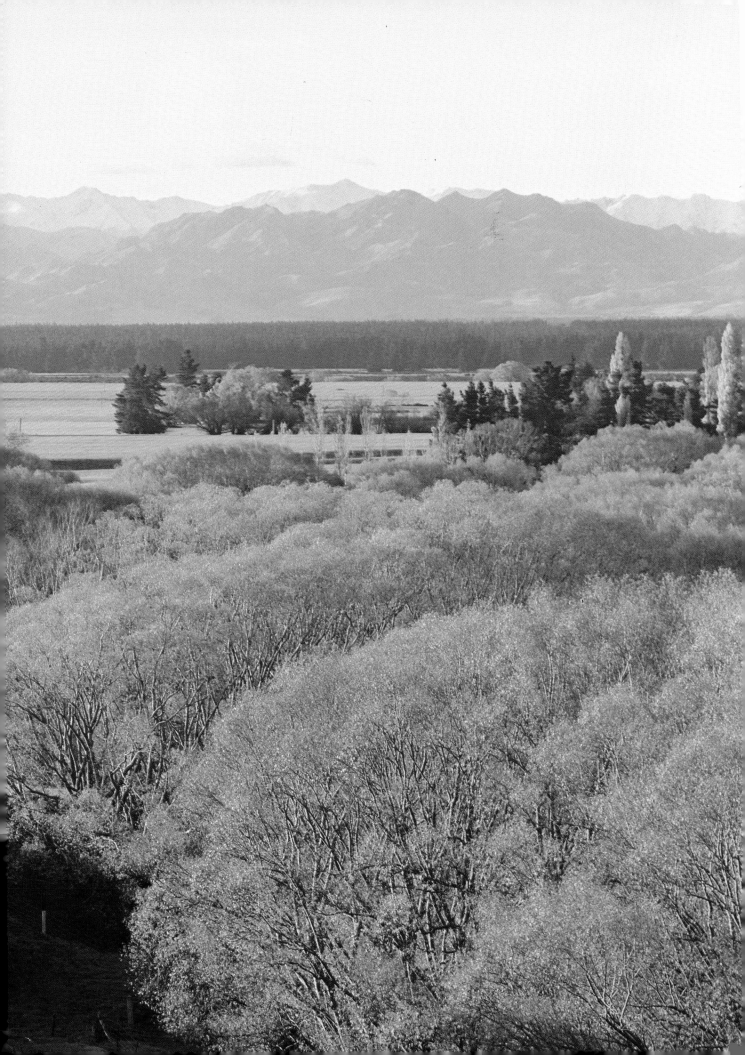

The biggest lakes, the longest rivers . . .

Otago begins at the south bank of the great Waitaki River; and from there it spreads out its treasures gradually, in a sort of ascending scale of beauty and wonder, so that just when you've come to the conclusion that there can be nothing left to see that is wonderful or beautiful or huge or sublime, another vista opens up that is even more fabulous than the last.

Travelling southwards, you see great sweeps of golden-sand beach, sheltered at intervals by high headlands and reefs, backed by steepening hills. Dunedin, the principal city, is a treasurehouse of Victoriana, still calmly conscious of the fact that it was a centre of civilisation and solid culture when northern towns were primitive collections of shanties.

South Otago has, tucked away in its hills and along its coastline, some of the most beautiful, least known scenery in the entire country. Fiordland almost numbs the senses. Central Otago combines stark, desert-like, awesome, rock-ribbed beauty with superb alpine scenery and a profusion of beautiful lakes and grand, powerful rivers.

Otago is rugged, an area of severe winters, redeemed entirely by summers that are temperate to hot. It is not surprising that the area seemed attractive to Scottish immigrants in the middle of last century, for it must, in many places, have seemed to have much in common with their homeland. Its hinterland, the high, tussock-covered hills, and the plateaux planed flat by ice-age glaciers, with the swift, deep rivers, the rocky skeleton of the land thrusting out through its alternatively burnt and frosted soil, was an environment the Scottish shepherd understood. The good harbours, navigable rivers and rocky coasts were familiar to the Scottish fisherman and coastal trader. The coastal hills, gentle enough to accommodate cities and towns, were inviting to shopkeepers and merchants; and the gold in the rivers and beneath the very tussock roots, while it might have made many desert honest industry for a dream of golden wealth, drew men from all over the country, all over the world, to found brawling shanty-towns which, however offensive to the tidy-minded Scottish townsman, had to be provisioned and were thus valuable to the shrewd merchants of Dunedin and Palmerston.

Otago is forests in the mountains west of Tapanui. Otago is crumbling gold-rush townships. Otago is vast hydro dams. Otago is a fishing village with small trawler-launches tied up to spindly-legged jetties. Otago is lonely hills furred with tussock that stirs beneath the touch of the wind like the rough pelt of an animal. Otago is lakes up to 80km long, with steep mountain walls and shorelines of ancient glacial moraine. Otago is fiords where mountains rise sheer from the water to heights of over 1500 metres, and waterfalls leap out from hanging valleys to plunge hundreds of metres into the dense forest below.

If Otago winters are severe, and Otago summers burning hot, Otago autumns are mellow with quick, early frosts which paint the countryside with gold and red; and Otago springs are palely, freshly green.

In Otago, hardy, high country sheep produce fine wool. Apples grow in rich, alluvial soil in the valleys, and apricots ripen on rocky ledges above the Kawarau and Clutha Rivers. Coal lies beneath the surface of its southern coastal land, and bands the seaside cliffs with shining black seams.

All in all, Otago presents, as I suggested earlier, infinite variety. People tend to think of it as a winter land, because its most popular and best known area is Central Otago, where there's snow on the heights for a long season's skiing, and the lakelets are frozen for skating and curling. Yet probably more people flock to Central Otago for its long, hot summers than ever go there for its excellent, world-class skiing; and in summer, its lakes are alive with power-boats and yachts, water-skiers and swimmers. Its coastal beaches are favoured playgrounds, at least partly because they are never over-crowded, and because the sea maintains a fairly constant, swimmable temperature the year round.

Be that as it may, Otago possesses the longest, most navigable river in New Zealand, the greatest lakes; some of the highest mountain peaks, the deepest, longest fiords. And all of them, happily, are easily accessible.

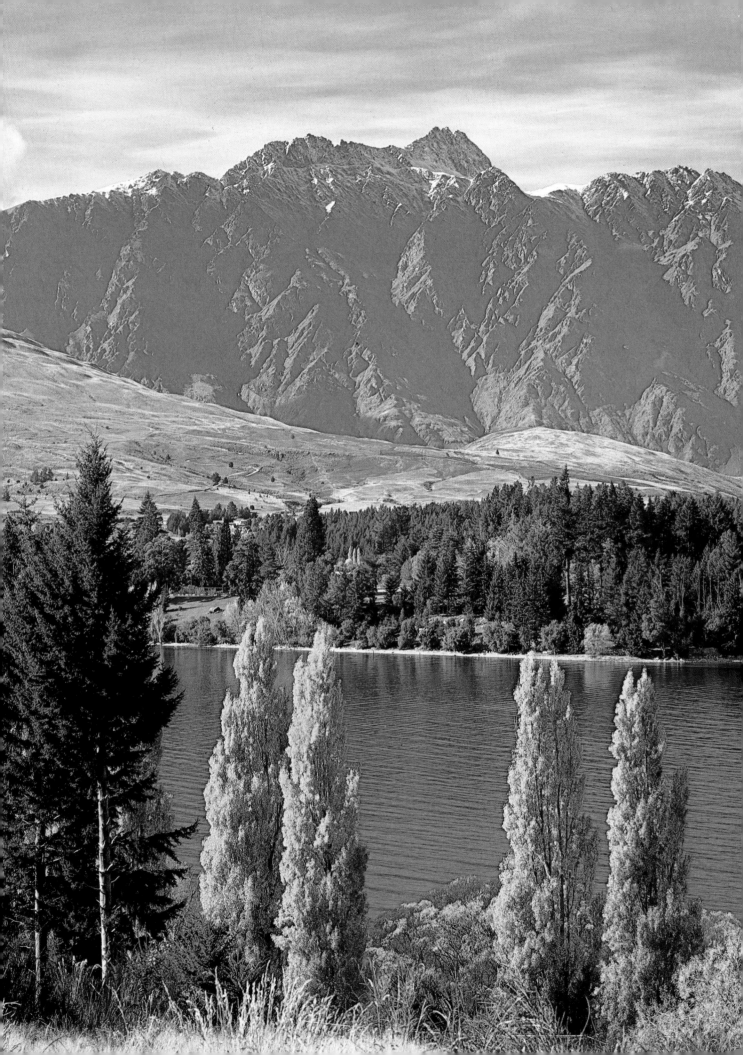

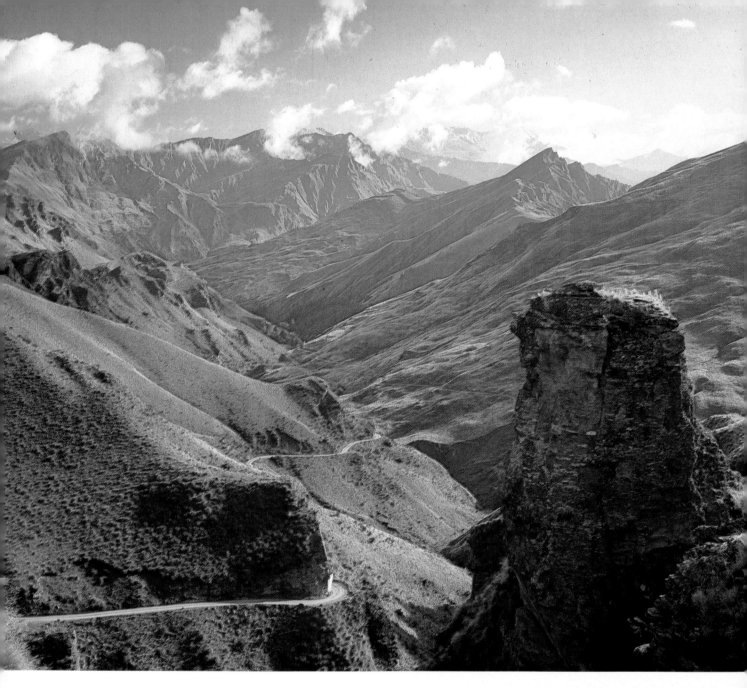

Above

Skippers Road is the famous — or infamous — way into Skippers Canyon, probably the most hair-raising drive in the country. Into rugged mountain valleys like this, men came searching for gold in the '60's of last century; and in this kind of country they built their rough shanty-towns and endured the cruel winters of these highland hills.

Previous Page

The Remarkables' rough, striated faces loom over the Frankton Arm of Lake Wakatipu, an eternal reminder that even when the lake and its shores are warm in the autumn sunshine, and the trees richly gold, and the grass still summer-brown, this is alpine country, and sundown will be followed by a quick, clear, crackling chill.

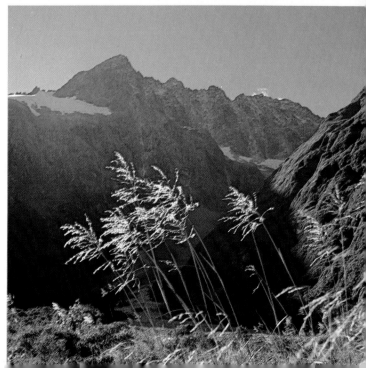

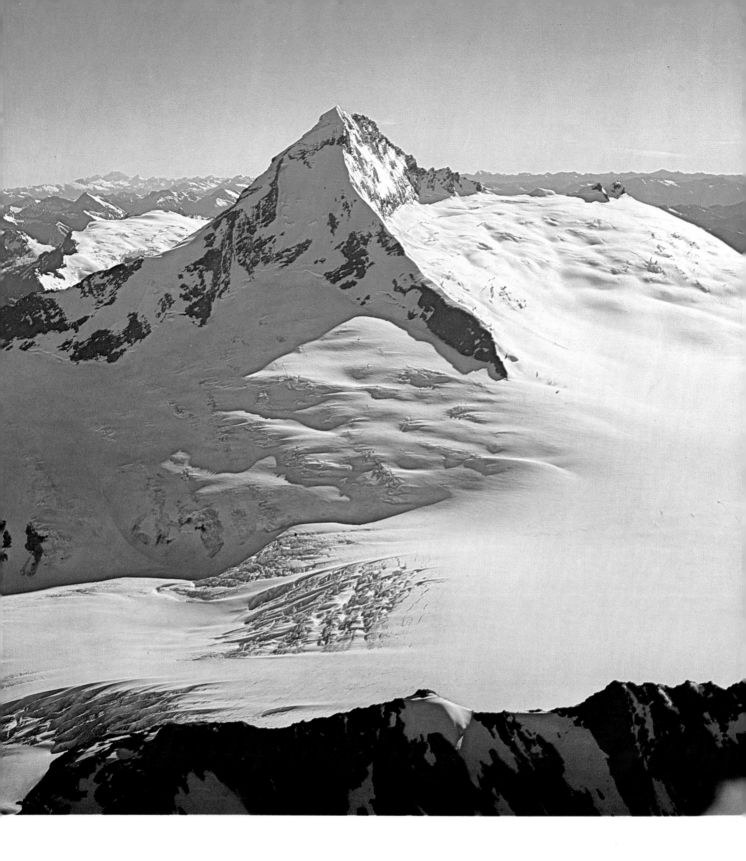

Left

Mt Crosscut is well named, a saw-blade of a mountain, its peaks cruelly jagged, with faces often so steep that snow seldom clings to them. This is avalanche country, and from the feet of such geologically youthful, unstable mountains, great fans of boulders spread filling the valleys and strangling the forests. Yet always the forest persists, and ultimately establishes itself over the gravel-heap ridges again.

Above

Mount Aspiring, towering 3,055 metres above sea level, lording it over the lesser peaks in the Mount Aspiring National Park, is always snow-covered, and its flanks are draped with no fewer than five quite sizeable glaciers. The peak is remarkably symmetrical, and extremely photogenic.

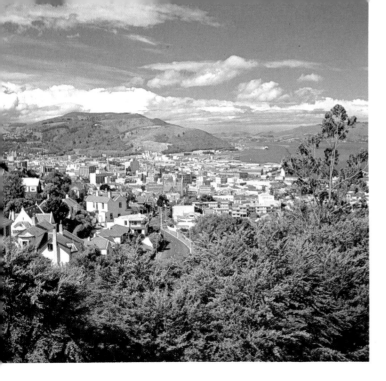

Above

Dunedin clusters thickly about its long, narrow harbour, but spreads out and gives itself elbow room among the surrounding hills. There are many fine Victorian mansions, not a few still occupied by the descendents of the merchants and professional men who built them, so that they have not fallen into disrepair, or been ruined by unworthy additions and alterations as in so many other New Zealand towns.

Right

The ample Green Belt about Dunedin was provided for by wise City Fathers. They were never rigid in the matter of issuing permits to build within it, with the result that today, hidden amongst these pleasant glades, are homes that are little islands of tranquility, insulated from the city's bustle and noise.

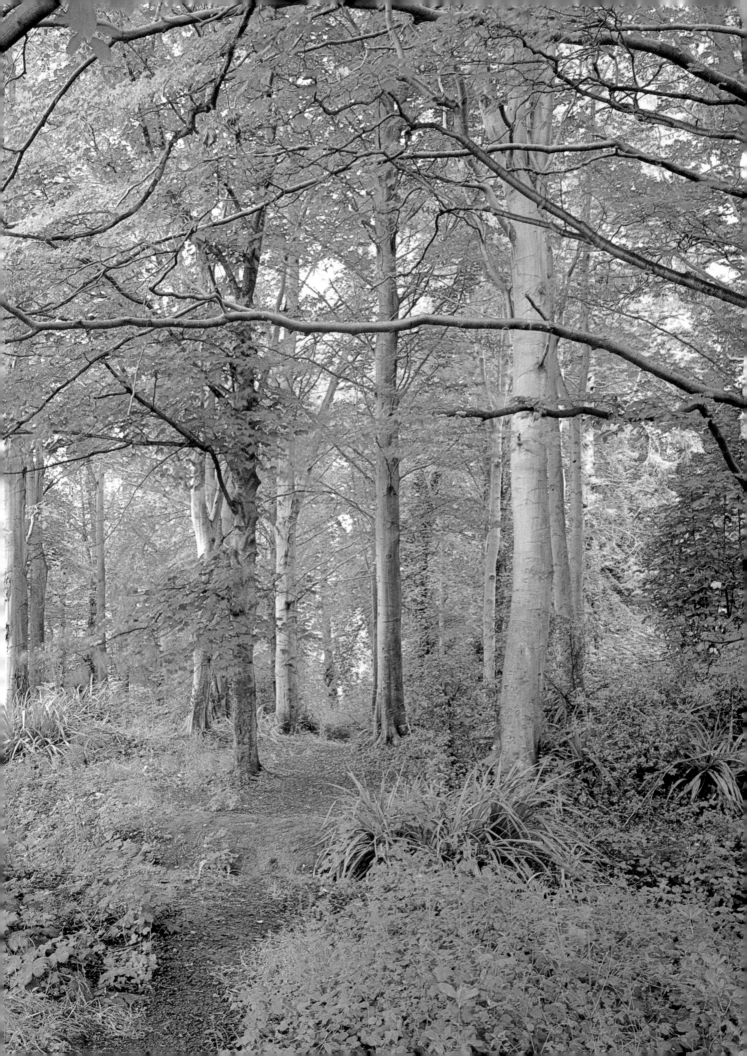

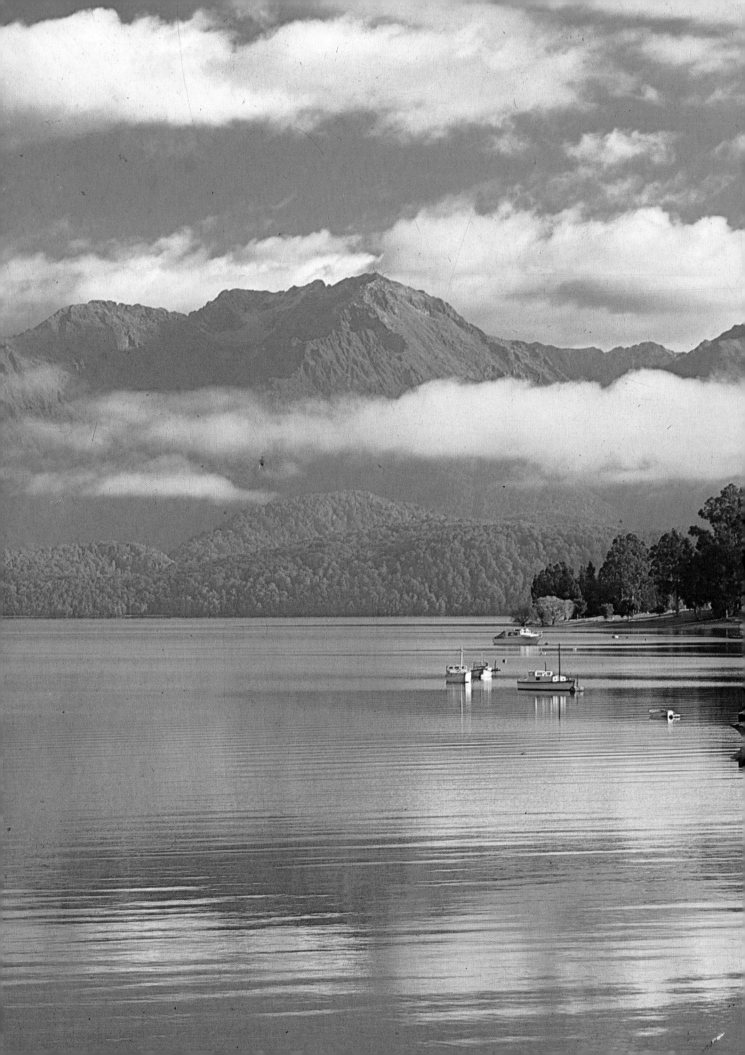

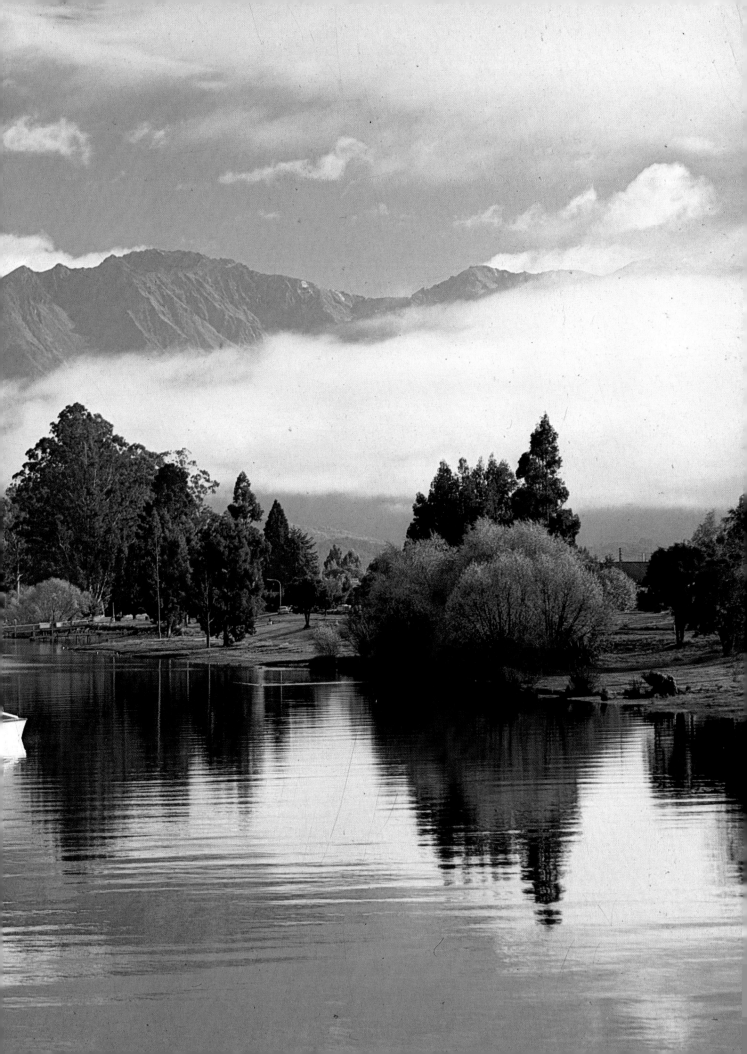

Previous Page

Te Anau is the largest of the famous Southern Lakes. Some 54km long, with a width of up to 9km, it lies at an altitude of almost 212 metres, and its bed is below sea level. The lake divides into four arms, Worsely Arm, North Fiord, Middle Fiord and South Fiord, separated by lofty mountain ranges.

Right

This face of Mount Christina, along the road to Milford Sound, is typical of scenery which is perhaps the most spectacular in New Zealand. Such tremendous mountain faces, such great walls of rock, line the way for mile after mile. During periods of heavy rain, and for up to an hour after rain stops, these faces are festooned with white and sparkling ribbons of waterfall, which disappear as suddenly as they came, until the next rainstorm.

Below

Mitre Peak must be the most photographed, most painted peak in New Zealand. When approached by launch, the famous mitre-shaped mountain resolves itself into a long, jagged ridge, the peak rising sheer from the water of Milford Sound to cover 1500 metres. Such is the height of these magnificent peaks that the waterway between them seems narrow indeed, and it comes as something of a surprise that the launch takes so long to cross its up to 3km width.

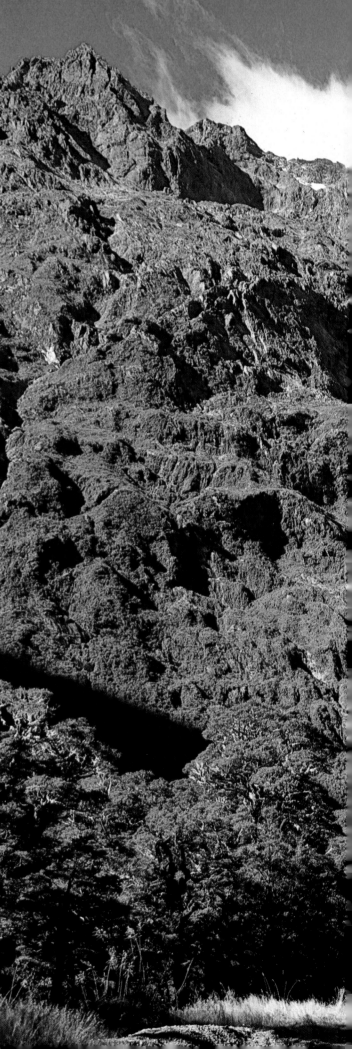

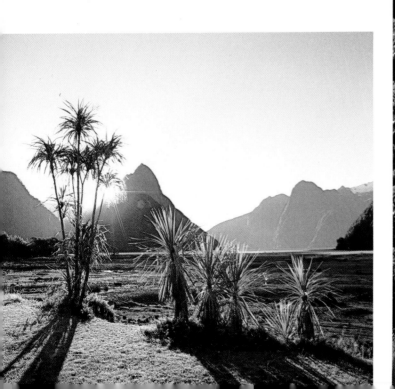

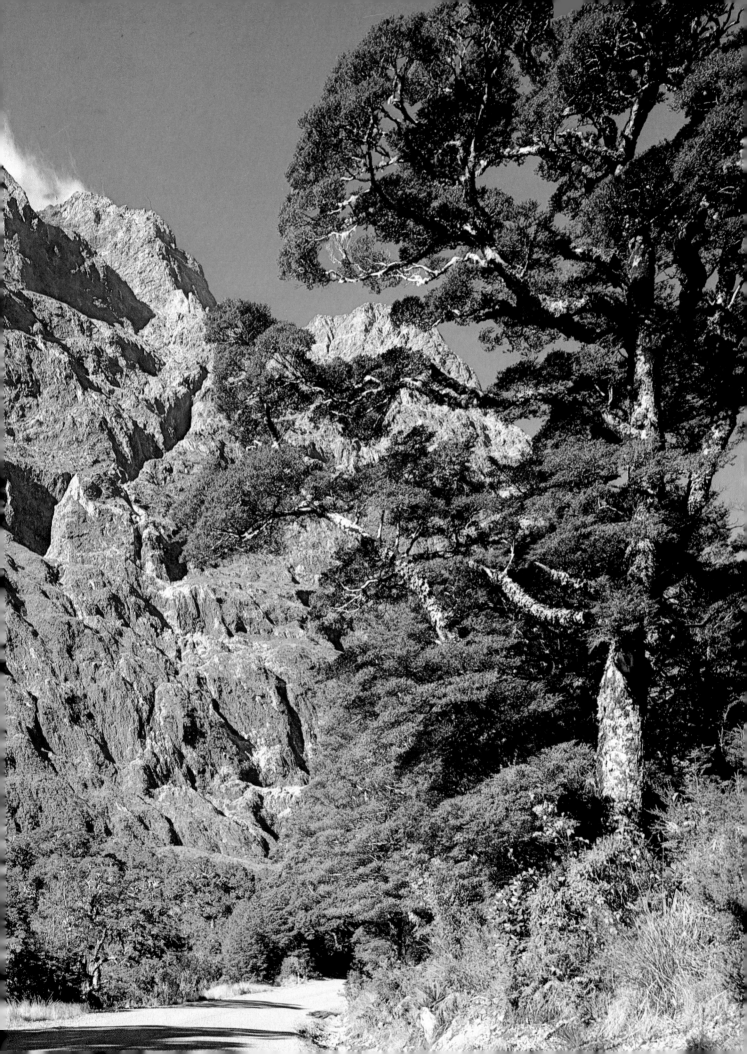

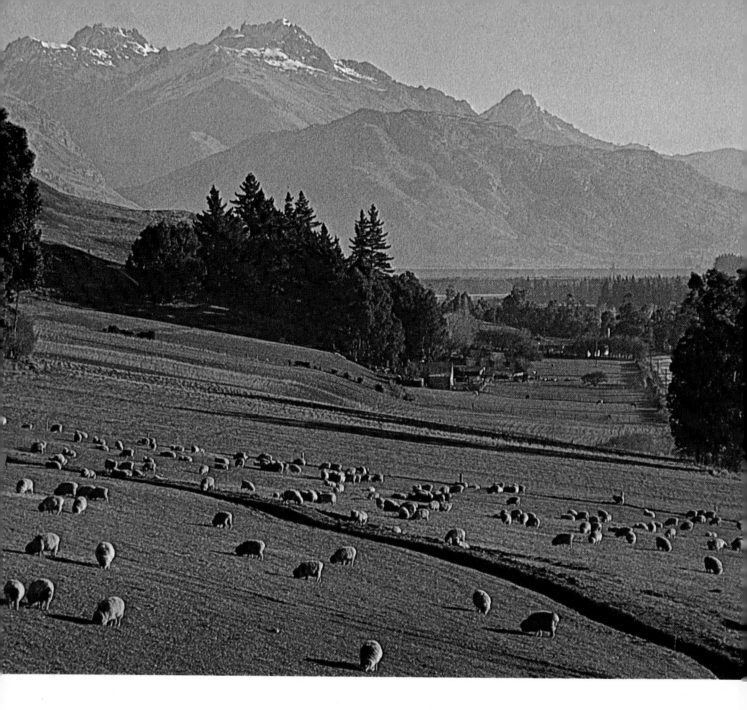

Above

The Arrow Basin is a fertile complex of valleys and flats north of Queenstown, in Central Otago. A onetime gold-mining area, it quickly attracted farmers, who were assured of good markets for their meat and produce in the mining settlements in the surrounding mountains. Severe winters and torrid summers give the area a seasonally varying display of rich colourings and characteristics unmatched by the lowland and coastal climate zones.

Above Right

The Karitane Coast, just north of Dunedin, presents a pleasant vista of curving, sandy beaches, the bays deeply enough indented to be sheltered and safe for holiday-makers and small-boat fishermen. It is typical of the North Otago coast, with its near farmlands and tiny hamlets spread almost to the water's edge.

Below Right

Edievale's rolling downs, neatly fenced, lushly green, softly loud with sheep, are rendered even more gentle-looking by contrast with the backdrop of the wild, forested Blue Mountains. In summer, the higher hills hereabouts are brown, furred with tussock that flattens in wheals along their flanks beneath the northerly winds.

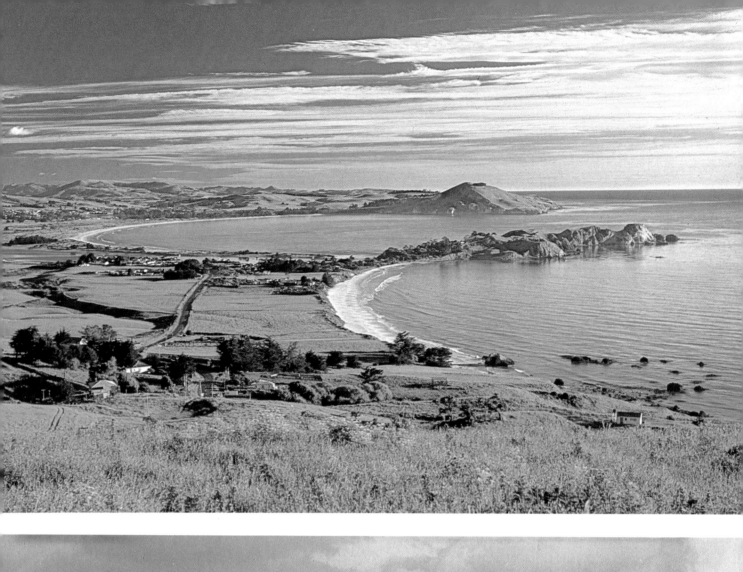
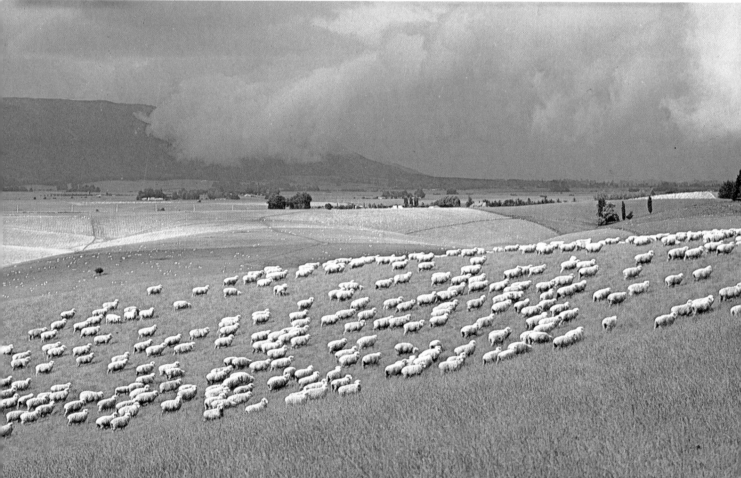

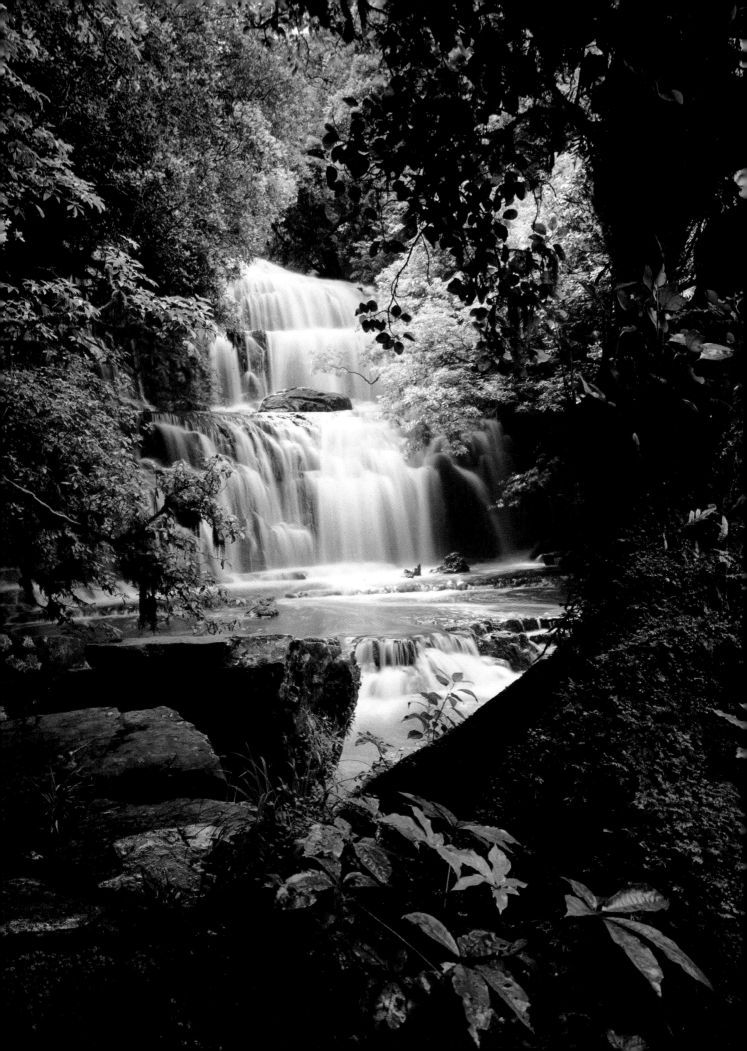

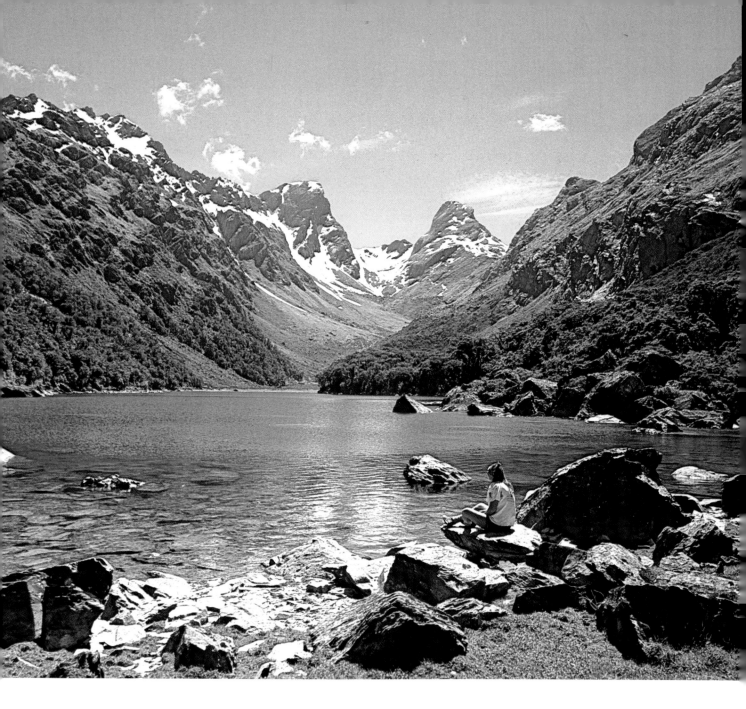

Above

Lake McKenzie lies along the Routeburn Track, a walking track which runs between the Milford Road near Lake Lochie, through mountain country to Kinloch, at the head of Lake Wakatipu. This view is to the north, to the snow-capped heights of Mount Emily and Ocean Peak, and is typical of the alpine scenery along this route.

Left

South Otago's Purakaunui Falls are one of the region's scenic attractions that deserve to be much better known. In the Catlins area, they are reached by way of a short ponga-paved track through exquisite native bush. The falls provide an enchanting climax to a brief walk unusually rich in beauty and interest.

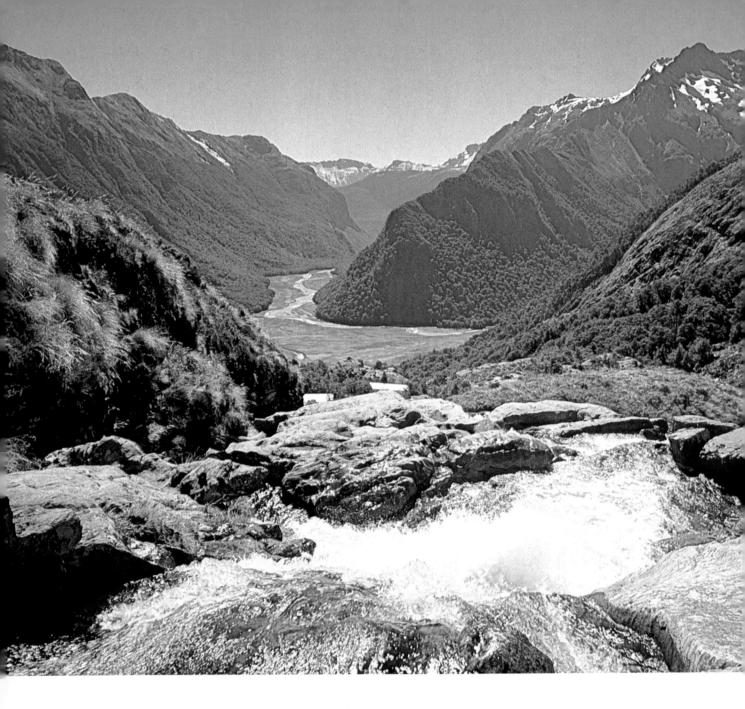

Above

Mount Homus towers over the Route Burn Flats, a pleasant, unexpectedly pastoral-looking valley hidden in the midst of alpine splendour along the famed Routeburn Walking Track. The Routeburn is second only to the renowned Milford Track for its magnificent mountain scenery. This stretch runs between the head of Lake Wakatipu and the Hollyford Valley.

Published and designed in 1980 by
Kowhai Publishing Ltd.,
59 Cambridge Terrace, Christchurch.
and
10 Peacock Street, Auckland.

Copyright © Robin Smith Photography Ltd.
Typesetting by Quickset, Christchurch
Layout: Wendy Attwood
Cover design: Ian Munro
ISBN 0-908598-02-5
Printed in Hong Kong

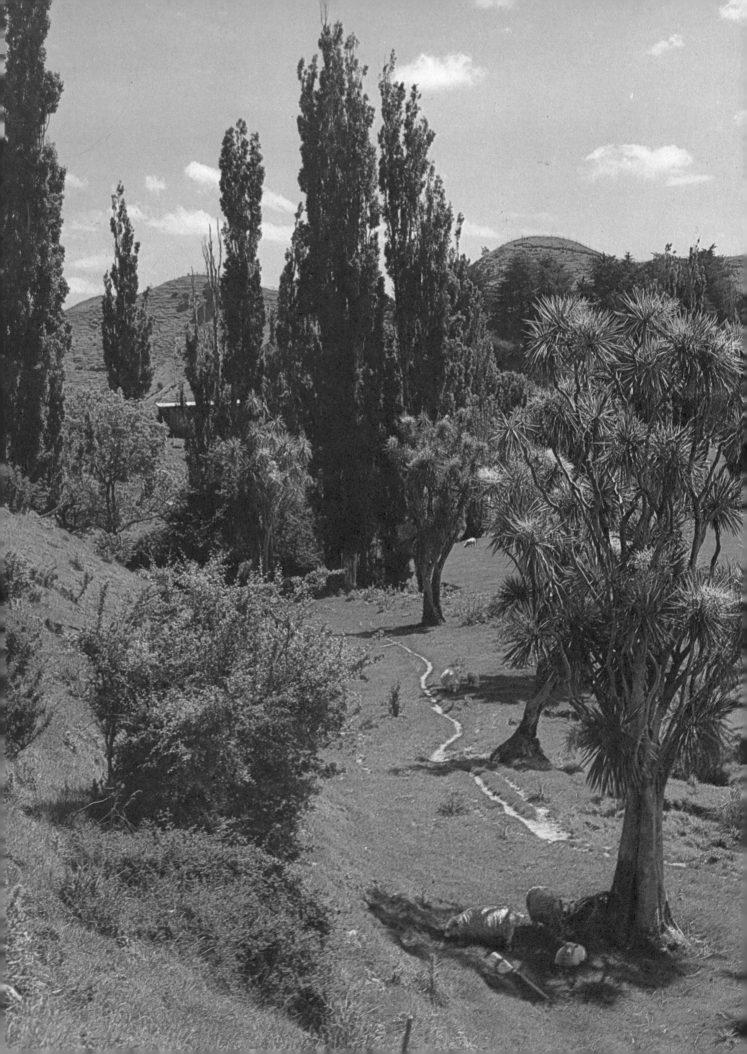